The Bison in Art

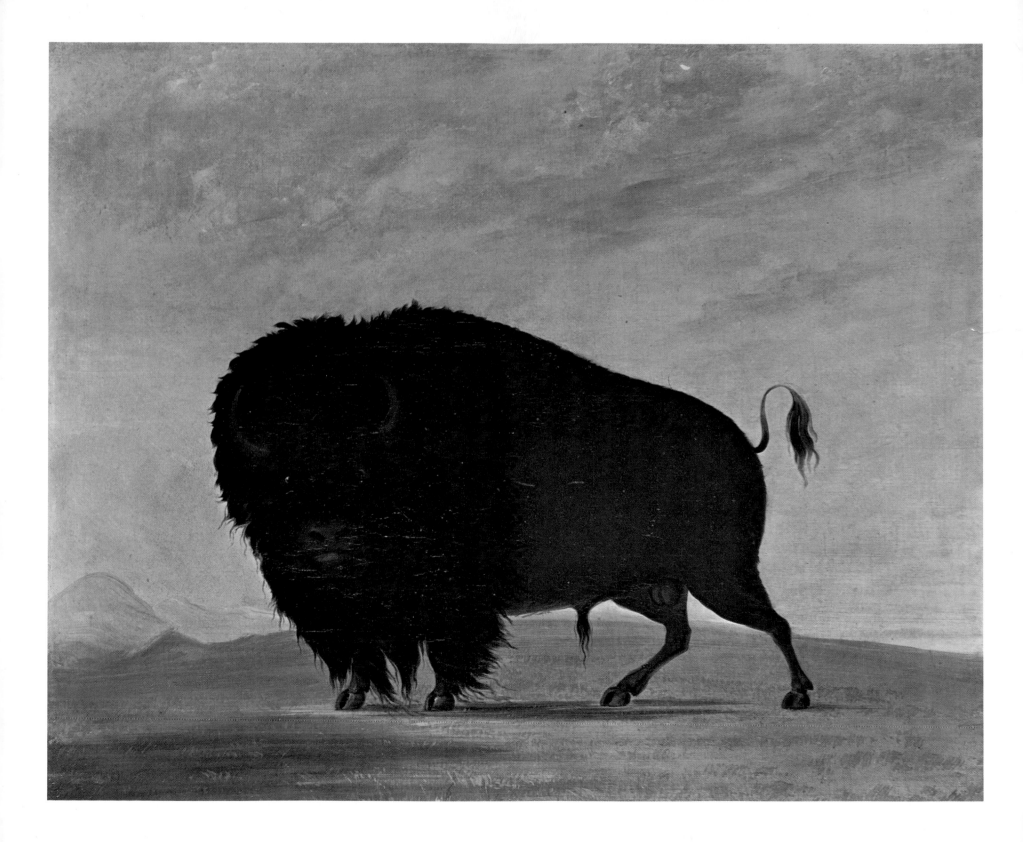

THE BISON IN ART

A Graphic Chronicle of the American Bison

BY LARRY BARSNESS

Foreword by Barbara Tyler

PUBLISHED BY NORTHLAND PRESS IN COOPERATION WITH

THE AMON CARTER MUSEUM OF WESTERN ART

Frontispiece: BUFFALO BULL GRAZING ON THE PRAIRIE. George Catlin, 1832–1833. Oil on canvas. 24 x 29 inches. Lent by the National Collection of Fine Arts; courtesy the Department of Anthropology, Smithsonian Institution. *Catlin understood correctly that Indian culture rested on the bison, and included many bison pictures among his studies of the Indian way of life. This portrait of a buffalo bull is particularly successful, capturing the wary confidence of the animal which dominated life on the Western Plains.*

The Amon Carter Museum was established in 1961 under the will of the late Amon G. Carter for the study and documentation of westering North America. The program of the Museum, expressed in publications, exhibitions, and permanent collections, reflects many aspects of American culture, both historic and contemporary.

Copyright © 1977 by Amon Carter Museum of Western Art
Fort Worth, Texas

FIRST EDITION

ISBN 0–87358–158–x

Library of Congress Catalog Card Number 76–52543

Composed and Printed by Northland Press in Flagstaff, Arizona

Contents

Foreword

EXHIBITIONS ARE THE BUSINESS of museums. They come and go with steady regularity — visual tributes to our distant and not-so-distant past. The gestation period for some is less than a year; for others, it is agonizingly slow (this one took close to twelve years). But most, especially art exhibits, are short-lived. Once dismantled they would be soon forgotten were it not for the catalog, that printed recollection of a more vibrant testimony.

The story of the American bison has been told so often one wonders why it bears telling again. We asked ourselves that question in 1965 (back then I was still Curator of History at the Amon Carter Museum and had no thoughts of moving to Canada), which is about when our first discussions on this topic took place. Then, as now, it was the intriguing mixture of myth and reality that made it attractive. To a significant portion of America's native peoples, the buffalo was survival. Few animals have provided man with more. From brains to blood, hoof to horn, no part or particle of the buffalo went unused by the Plains Indian. From this prairie species came food, clothing, shelter, tools, utensils, ceremonial objects, fuel, toys and home remedies. Even the tail served adequately as knife scabbard or fly swatter. Because there were millions roaming the prairies, no one perceived the day when the great herds would disappear. Then came the Europeans.

The white man exploited the buffalo for commercial gain, wasteful sport — a favorite of the nineteenth-century jet set — and a means to bring about the capitulation of the Plains Indian. Uncontrolled slaughter reduced millions to a few strays, and the age of the buffalo ended. Among North American mammals and their feathered counterparts, whose natural and evolutionary processes have been so markedly affected by the arrival of man and his industrial revolution, the bison stands out as the most tragic victim of man's greed.

Our courtship of the buffalo began in the storage vaults of Amon Carter Museum where were stored more than forty paintings and sculptures — almost all by Charles M. Russell or Frederic Remington — of bison grazing, bison dying, bison stampeding or bison standing majestically, undeniably king of American beasts. Over the years, the vault's collections grew and so did the number of buffalo paintings and illustrations. Across the country in other museums and art galleries specializing in Western Americana, the situation was the same. It was obvious the bison was a favorite of early western artists.

Despite numerous books and memoirs recounting the rise and demise of the bison, we knew of no book nor of any exhibition which featured the variety of artistic tributes. There was no accounting for the grotesque representations

by early European and American artists whose works were not done from firsthand knowledge or even memory, but from descriptions brought home by early explorers or adventurers; no attempt to distinguish between the realistic and the heroic, fanciful ones exaggerated by the artist's eye; and finally, there was no attempt to explain or expose both folklore and fact using the countless visual documents in our galleries and archives. That was reason enough to pursue the matter.

The exhibition took an unreasonably long time to produce but not because the paintings, illustrations, photographs and sculpture were difficult to find. That part was easy. There were hundreds. It was difficult to choose a representative selection, and sometimes harder to negotiate the loans. The greatest dilemma, however, was finding an author — one who not only knew the history of the bison but the nonhistory as well. Larry Barsness took a long time to appear.

This, then, is the after life of an exhibition — and more, much more. It is an apologia to an animal, a documented account of a not-so-illustrious page out of our past, and a tribute to those artists and illustrators whose works force us to remember.

BARBARA TYLER
Assistant Director Public Programmes
National Museum of Man
National Museums of Canada

The Bison in Art

A FUR TRAPPER ONCE DESCRIBED a friend as "a big feller with hair frizzed out like an old buffler's just afore sheddin' time"; he used the natural buffalo analogy that would allow his hearers to see the "big feller" in a meaningful image. Buffalo images popped out of the mouths of fur trappers because the beast had imprinted so many images in their brains. When a simile jumped up, it likely used the comparison with buffalo doings. They spoke of bravery as "brave as a buffalo in the spring"; it was the opposite of "I run as ef a wounded buffler was raisin' my shirt with his horns."

Indians, too, used buffalo metaphors. Crows described the circumference of a tree as one robe, two robe, or three robe — a visual estimate of robes necessary to reach around it. The expression "Drop his robe" meant that a man died where he stood — with his boots on, if you will. Sioux Indians named each winter after an outstanding happening. "Winter when the buffalo stood among the tipis" meant a good winter; on a hide calendar a stylized sketch of buffalo among tipis would depict its goodness. Likewise, Indians used the buffalo image to symbolize and name various months of the year: thin buffalo moon or moon of much buffalo hair. . . .

In the West we've named the low, gray orange-berried bush "the buffalo berry"; in the East we've named the buffalo nut, it's black and two-horned. Today, we understand the term buffaloed, although, since we see no more encompassing herds, we no longer see the image that brought it into our language, but we might still see the image in "Dead as a buffalo chip."

Buffalo images help us to see an image of what the West was — an Eden filled with these pastoral wild animals, an adventureland filled with buffalo to chase, a wonderland filled with more big bodies than any other place on earth, a playground where one could plink at the biggest targets of our continent's outdoor shooting gallery, a mine of hides and tongues to be worked and forgotten . . . a symbol of America's diversity of experience.

Artists saw all of this and captured it on sketch pad, on canvas, on wet plate and film. Their pictures of buffalo reveal much of what attracts us to the West of yesterday. . . .

No European arriving on the North American continent during the centuries before our own could remain free from involvement with the fact of this beast. In the East the New Yorker in his sleigh bundled under a buffalo robe, the Kentucky frontiersman ate buffalo and neglected to clear the forest, the butcher speared smoked buffalo tongue from brine, the traveler along the Mississippi followed buffalo

trails through the canebrake, the housewife sewed on buffalo bone buttons. In the West the homesteader raised no cattle because he could kill buffalo for his table, the fur factor fed buffalo meat to his employees, the pig farmer shot buffalo to provide meat for his pigs, the 49er played with buffalo calves and then butchered them, the thirsty stoned lolling buffalo from a waterhole, travelers set fierce dogs on wandering buffalo to keep them out of camp at night.

North America was buffalo land. Never on any continent had an animal of this size expanded into such a population — 30 to 60 million.

Nor did the buffalo population expand just because the plains climate suited them. Prehistoric species had lived in the Arctic tundra. Probably buffalo emigrated to our Arctic from northern Asia 50,000 to 80,000 years ago, trying to escape pressure from hunters. He and they crossed the then-existent land Beringea, a grass-covered link between Asia and North America, revealed only when the Ice Ages impounded much of the world's water in ice, thus lowering the ocean level. When he and his pursuers reached Mackenzie Bay, they found themselves beyond mountain barriers and for some reason turned south. Both followed the great Mackenzie River valley to the open grasslands. Here extended thousands of miles of forage, water and trees and brush, the perfect home for grasseaters.

Eventually buffalo ancestors overflowed the home. Some swam the Mississippi to live among eastern forests; others moved south into the desert, at least as far as Culiacan, Mexico, perhaps even to Nicaragua; still others walked over the easy, pasture-like Continental Divide between the head of the Missouri and the head of the Columbia and made their way to Oregon and upper California. But all of these disappeared to be replaced by our two modern sub-species *Bison bison bison* and *Bison bison athabascae*. These, too, increased to the extent that they had almost filled the con-

tinent above the Rio Grande when European man arrived.

Bison lived most successfully on the open plains and *athabascae* in the woods; *bison* lived in greatest concentration on the Kansas high-protein grassland and *athabascae* in arctic forest. These subspecies look alike — it takes a zoologist's analysis to tell them apart. *Athabascae's* skull and horn cores average larger than those of *bison*. They differ also in their habits and preference of habitat, and for that reason they're known as the wood buffalo (*athabascae*), and the plains buffalo (*bison*). The wood buffalo, like most *Bovidae*, prefer the cover of woods and brush. Although they graze in the open during the day, they retire to cover at night. The plains buffalo lost this habit — life on the plains forced them to — and live contentedly in the open. Consequently wood buffalo live in smaller groups forced upon them by the forest, nor do they roam as erratically as the plains buffalo.

The wood buffalo stands higher than the plains buffalo and outweighs him. Those with the eye for it would notice that he's blacker — less sunbleached, perhaps — than his cousin, and his beard is shorter, worn off in the brush. But they have the same habits and live much the same yearly life.

At one time the wood bison lived south of his arctic range, roaming the high Rockies as far south as Colorado. Sometime in the 1800s he disappeared from this southern region, killed by hunters.

LAST OF THE BUFFALO. Albert Bierstadt, 1888. Oil on canvas. 60 x 96 inches. Courtesy Buffalo Bill Historical Center, Cody, Wyoming. *"I have endeavored to show the buffalo in all his aspects and depict the cruel slaughter of a noble animal now almost extinct,"* wrote Bierstadt. *The painting was rejected for inclusion in the Paris Exposition of 1888, but nonetheless stimulated sufficient public sentiment to cause the first official census of the surviving herds.*

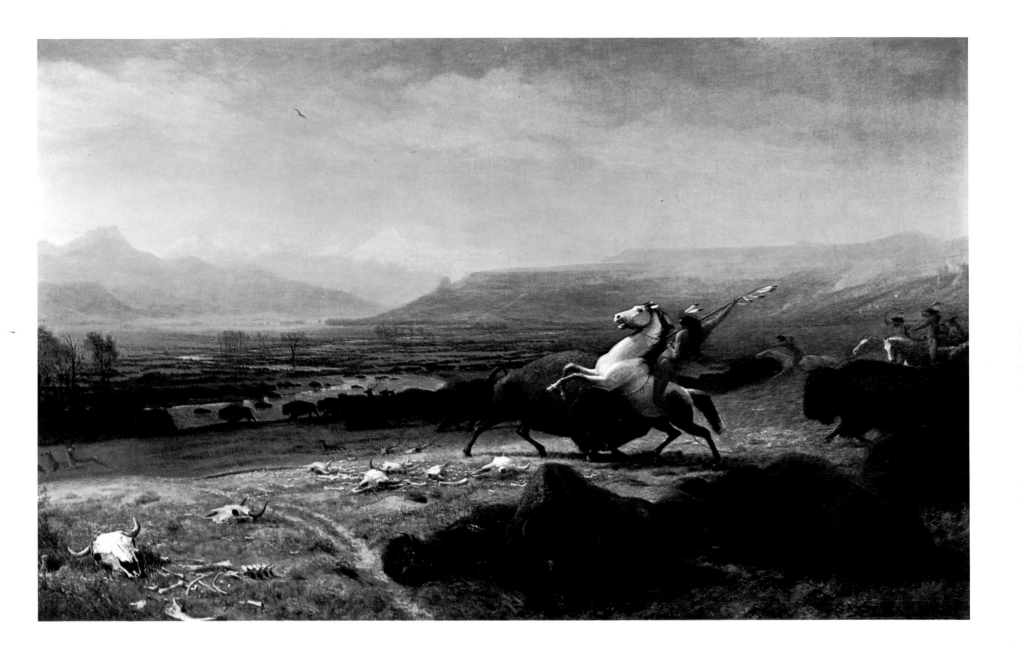

If a drouth stunted grass, these modern buffalo foraged on brush; when water holes dried up they went for days without water while they moved to wetter land — perhaps to high mountain elevations. If deer, antelope or elk intruded on pastures, the herd may have formed a phalanx, advanced and moved them off (prehistoric, larger bison species may thus have driven the tapir and the sloth from critical pasture and starved out these species). When deep snow covered the grass, buffalo rooted it aside to feed; when the blizzard howled, they stayed snug in their woolly winter coat — but they shed it before the hot summer came. They, unlike other large animals on the continent, could live anywhere on it, from tropic to arctic, swamp to desert, mountain peak to ocean beach.

An occasional hungry grizzly bear may have attacked a full-grown, healthy buffalo, but no animal attempted to make daily meals by attacking such size and such dagger-like horns. The grey wolves that ran through the herds like buffalo pets fed on the old, sick and young; only a cow with a small calf and those animals staggering from injury or old age eyed them warily. Prairie fire occasionally ran some buffalo down, blinding them; an early winter sometimes froze a herd into a pond to starve; a late spring blizzard sometimes killed thousands of calves; summer tornadoes sometimes tossed a herd into the next drainage, but such accidents reduced the millions imperceptibly. The beast's own instinct did in more of his kind than nature's accident: in the spring he followed-the-leader onto weakened ice to fall through and drown. One spring day John McDonnell, on the Qu'Appelle River in Canada counted 7,360 bodies floating by before he had to give up counting. But none of these deaths threatened the survival of the species. Only the arrival of the European man did that.

Probably buffalo lived longer than most North American animals; animals thirty years old live in today's herd. And cows continued fertile at twenty-five, even thirty years old. Baby calves six months old could outrun wolves; if caught, though hornless, they stomped and kicked some attackers to death, and perhaps escaped. A buffalo herd can outrun the usual horse, especially one burdened with rider. In spite of bulk, a buffalo can scale bluffs with the agility of a mountain goat; he can jump six-foot obstacles.

Small wonder this animal lived in such numbers on our continent.

Asian man eventually filled this continent as well as the South American continent. Though he'd arrived here pretty much as a buffalo hunter (at least a hunter of big grass-eaters), now he lived more variously. He raised corn in most arable places. He gorged on salmon in the Pacific Northwest and shellfish in the Atlantic Northeast. But he lived most leisurely from the western banks of the Mississippi to the Rockies, gorging on the big, red-meated, warm-blooded buffalo, using the rest of his carcass for all manner of useful things.

These hunters, descendants of the spear-carrying Asian, practiced all the skills learned in 100,000 years of killing buffalo on foot. Some of them ran swiftly enough to dash among a complacent herd and spear a beast or two before it stampeded away. But they knew surer ways. They moved the buffalo into any spot they chose by gently spooking them, showing themselves slowly moving along the flank of a herd to move the herd toward them, for buffalo try to cross in front of any enemy flanking them. Flankers on the left and right and chasers in the rear could move a herd into swamp, river or lake and there kill the animals as they struggled (sometimes men carrying daggers swam amongst them to kill them). In the winter such herdsmen could mire a herd in deep snowbanks or immobilize it on slippery ice-covered ponds.

If tough foot-hunters lived in timbered country, they could trouble themselves to build a corral — and gently drive the herd close by until they could startle it into the pound. If they lived among rocky cliffs, they could construct a corral at cliff-bottom, gently drive the herd nearly to cliff-top, then startle it into a stampede over the drop-off. (They wasted a lot of meat this way, for bulls went over the edge as well as cows — and no one ate bull meat when he could have cow. And much of the liver and entrails — parts they could not sun-dry or smoke — rotted.)

These foot-hunters donned wolfskins to creep among the herds, taking advantage of the nonchalance with which buffalo viewed wolves amongst them. These foot-hunters daubed themselves with dust and lay in buffalo trails to surprise the beasts as they came single file down from the hills to drink; they ambushed the beasts at water holes, ringed the beasts with fire, encircled them with hunters. Sometimes they stood upwind and lighted handfuls of grass to drift smoke into the herd and move it little by little nearer to camp — to ease the job of carrying meat.

These foot-hunters knew all of the buffalo's instincts and played upon them; furthermore, they, lucky hunters, lived amongst unwary herds that, unlike deer or elk, sometimes of a night came grazing amongst the tipis or about the camp's outskirts.

French explorers found such hunters along Eastern rivers and along the Mississippi. Early Spanish explorers found them killing buffalo along the Pecos, the Canadian and the Cimarron, gathering hides to trade for corn in nearby pueblos and assure good winter living.

Buffalo hunting peoples, adventuresome, uninterested in farming, loving the wandering life more than the sedentary, followed the herds. They visited strange drainages and now and then met up with other wanderers, strangers who spoke unintelligibly, but didn't threaten them (there were plenty of buffalo for all). Over the years they encountered enough strangers to develop a sign language that enabled them to talk and trade together. All of these wanderers among the buffalo became a little more sophisticated than the stay-at-home corn raisers or salmon eaters. They knew they needn't run, frightened, from all things strange, or, frightened, try to kill the stranger.

And since the buffalo provided most necessities to these wanderers, each group came to revere the beast, the giver of all; they came to place him and the sun at the center of life, as the givers of all life. They prayed to the sun each morning; they prayed to a buffalo skull after cleansing themselves in the sweatbath. Many of their ceremonies, even among groups who differed in language and dress, revered the buffalo skull and used both it and the buffalo tongue in religious ceremonies. All groups danced a "sun" dance; all danced various fertility dances and hunting dances using buffalo paraphernalia. They saw magic in buffalo things. Some peered into a mixture of buffalo and badger blood to foretell the future; some threw bits of buffalo meat into a river to see if it floated or sank, to predict the safety of a crossing. All groups believed in the magic of buffalo dreams as the most powerful of dreams. Members of all groups went into the wilderness to fast and dream of an animal savior — hopefully a buffalo. All groups hoped for an afterlife in a happy hunting ground filled with buffalo.

Undoubtedly some groups died out and some groups melded, over the thousands of years between the appearance of Asian man and buffalo on our grasslands and the coming of European man. But somewhere man always wandered among the herds.

He learned to herd the buffalo so that he might keep "his" animals nearby. He could then stay longer in one place. Such groups knew of pleasant camping spots — places you and I would choose to picnic; they knew ways to keep

the buffalo close by, hunting methods turned to herding methods; a little smoke drifting downwind turned back a herd heading away; a display of moving human bodies along the horizon edged a restless herd back into nearby grazing land.

During summer, life amongst the herds meant pleasant gatherings of many tribal groups together, for now the herds gathered in enormous careless swarms, their energies and attention swallowed by the urgency of the rut; a man with a bow or spear could move almost unnoticed out of coulee or willow brush to down the animal he chose.

And what a feasting one downed animal provided. Immediately following the hunt, meat still body warm; thin-sliced liver laced with drops of gall, mouthfuls of warm large intestine yet full of chyme. A hundred pounds of innards and four hundred pounds of meat from a fat cow carcass. This was not a carcass with barely enough meat to feed a family group for one day, such as a deer carcass; here was meat for a hundred people for one day. Here was meat for hundreds of dogs. (These hunters had domesticated him as pack animal — possible because the buffalo provided the enormous supply of meat necessary to feed the hundreds they kept.) Amongst the buffalo herds, a man needn't hunt, hunt, hunt most of the days of his life for fear of starving. A few animals down meant days free for game playing, storytelling or idling. (A man needn't fish or trap; few buffalo hunters trifled with such food gathering; in fact they lost many of these ancient hunter skills.) At night, after a big hunt, warm orange light gleamed late through tipi-skin. Around the camp babies wailed with tummy-aches brought on by gorging. The lucky hunter feasted his friends, serving tongue, dripping ribs, and yards of roasted gut, turned inside out, stuffed with meat, spitted and roasted over the coals. He saved the delectable marrow for the old people, the only meat their gums could chew.

In winter, people lived in somewhat smaller groups than in summer, although living on buffalo allowed larger groups to stay together than did living on deer or rabbit as in the North and East. They camped in sheltered places near the woods and river bottoms where buffalo might winter. In nice weather, men hunted; in cold they sat at home and ate pemmican soup and dried meat. But they complained of starving, meaning they wanted fresh meat. Few buffalo peoples starved. They went into winter camp with tons of dried buffalo meat, enough to carry them through most any winter. Winter, then, was a time of peaceful relaxation, of storytelling, of game playing, of gambling. These nomadic hunters stayed quietly camped for long periods during both summer and winter thanks to their ability to herd and butcher the buffalo.

Over the ages such people had learned to use all of the animal: the hooves for hammers and glue, the horns to carry hot coals to the next campground, the tail as an expunger for the sweatbath, the ribs as sleds, the stomach and pericardium as water jug when suspended from three crossed sticks (like stool legs). And the luxuriant cowhide, taken in the full fall pelage, made the warmest bedding or winter capes; taken in the summer's shed condition it made tipi skins. Bull hides, especially the tough neck skin, made durable shields or, when covering a bowl-like frame made from willow sticks, a useful boat. Teeth, bones, sinews made hundreds of other things.

Europeans found buffalo-hunting nomadic peoples on the prairies and high plains whom they called savages. Yet these independent men and women lived far more comfortable lives, had far more time to devote to practicing their religions, more time for speculation and ceremony, more time to while away in gambling, in game-playing, in caring for the young and old — more time for doing as they pleased — than any European peasant, craftsman or soldier. They were

not, at birth, bound to a lifetime of drudgery in the fields or manufactories as was the average European; they needn't work most of the hours of their lives for fear of starving as did most Europeans. As Tom LeForge said, of living with the Crows, "It was a great life. At all times I had ample leisure for lazy loafing and dreaming and visiting."

This carefree life became even more so when it gained the European's horse, not only because the pack horse could carry more than the pack dog (the tiny skin tent women could carry or dogs could drag on tiny travois grew into the large tipi). The horse also meant transportation for the sick, the old, the wounded and small children. It meant women found life better. The horse carried butchered meat and hides from the slaughtering ground, cottonwood faggots for fires; she could load household paraphernalia on the big horse travois and plop a three-year-old on the load as well. She often rode galloping across the open land for the pleasure of it.

Pleasure. That's what the horse brought to the foot hunter. Horses let them ride to the far horizon just to take a peek over it, and then, unable to resist, a ride to the next far horizon, and the next. Curious Blackfeet from along the Missouri appeared on horseback among the pueblos along the Rio Grande; curious hunters rode to the Pacific Ocean and back. Tribes now found it possible to gather at a big trading meet; near the Mandans to trade for corn or in Shoshone country where one could trade corn and buffalo meat or hides for Pacific Ocean shells. Possession of the horse made the buffalo hunters an even more cosmopolitan people.

Gamblers by nature, these people loved to bet robes, tipis, even wives on the outcome of a horse race. Lazy days they often spent racing their horses — the sport of kings.

They rode the horse to herd the buffalo in all the ways they had developed as foot-hunters: to surround him, to herd him, to fool him as in Frederic Remington's *Indians Simulating Buffalo*; to fetch him from a distance and bring him to the pound for slaughtering. The engraving entitled *A Buffalo Pound* shows foot-hunting and horseback hunting combined. The man up the tree, the caller, has, on foot, enticed the buffalo into the pound; the man on horseback brings more buffalo; the iced ditch at the mouth of the pound keeps the buffalo from escaping; the hiding men will soon jump up to kill the beasts at point-blank range.

The horse, more importantly, added the pleasure principle to the buffalo slaughter: the buffalo chase. It added all the thrills of the horse race to the dull business of killing placid buffalo. But it wasn't much of a way to add buffalo meat to the tribal larder; the average horsed hunter brought down only two to three buffalo per chase. Nor could the average Indian afford a horse big enough and fast enough to go amongst the buffalo; generally only ten percent of the tipis in any village owned a buffalo horse. This meant that the man with a buffalo horse or two had the added pleasure of becoming a powerful influence in the village; he fed extra people, and those he fed became his followers. But the horse did not, as commonly thought, increase the ability of the buffalo hunter to kill buffalo.

The horse also meant hunters could travel quickly to a herd and quickly return with the meat. Equally important, it meant the lone hunter could move quickly to a buffalo he spied in the distance, even though he, when he came near, would probably dismount to sneak up on it. Probably owning the horse made the biggest difference to this lone hunter needing meat for just his tipi: the big chase on horseback brought excitement to his life, and the lone horseback hunt made him more sure of bringing in needed day-to-day provisions.

The horse increased the quality of his life — even though owning the beasts sometimes meant moving camp often just to provide fresh pasture for them, moves unnecessary before the horse. And someone had to continually guard them, us-

ually young boys. Horse-stealing between tribes caused a lot of warfare, but ritual war was pleasure to them.

Although the buffalo hunters had the horse for just a little more than one hundred years — tribes in the Southwest first obtained horses about 1700 and tribes in the North about 1775 — these people became some of the finest horsemen in the world. As such, they captured the imagination of the world. When people picture a North American Indian they picture him horsed — and, usually, chasing a buffalo.

As the European moved west from the Atlantic Coast he forced Eastern tribes west also. And as these tribes moved onto the open plains, they, too, became buffalo hunters. Cheyenne, Blackfeet, Assiniboin, all peoples of the East, learned buffalo hunting from the plains tribes and adopted their buffalo mysticism. The numbers of people subsisting on the buffalo grew, but the herds seemed still innumerable.

But, according to William T. Hornaday of the Smithsonian Institution, by 1832 no buffalo could be found east of the Mississippi, and by 1825 the herds had disappeared from Iowa, across the river.

The shrinking of the Eastern herds mostly came about because of the numbers of European settlers using the beasts as targets, shooting them but often as not leaving the meat to rot. Partly they shot because the huge beast, wandering in herds, trampled fields, wrecked fences, sometimes even buildings; a herd could gobble a small haystack overnight. Earlier, they'd trampled Indian cornfields.

Agriculture and buffalo made a poor mixture in other ways. They slowed agricultural progress in places other than Kentucky. The presence of Texas buffalo threatened the development of orderly civilization there. The Spanish émigrés found following the buffalo as delightful as did the native people; they tended to neglect their farms and follow the herds. Governor Cordero had to decree farm work in-stead of buffalo hunt. On Midwestern plains, the presence of buffalo may have retarded development of cattle ranching; the homesteader, by hunting buffalo, could provide enough meat for his family and farm the acres he would have needed for pasture.

The buffalo made possible much of the exploration of the West. The Lewis and Clark expedition ate well once it reached buffalo country but almost starved when it left it in the Rockies. Major Stephen Long's expedition through the Missouri country in 1819–1820 and the Zebulon Pike expedition along the Red River in 1806 subsisted on buffalo. And Pike's men not only subsisted, but also wasted, shooting extra buffalo each day, just for the excitement. Covered wagon caravans heading for Oregon and California tried to live on the buffalo, although those in the late 1850s found few along the Platte; either the herds avoided the great overland highway or earlier travelers had killed them off.

Buffalo meat supported the first great business ventures of the West, Canada's Hudson's Bay Company and North-West Company, the United States's American Fur Company and Rocky Mountain Company. The Canadian companies, dependent upon transporting furs across the continent by canoe and York boat, depended upon depots filled with buffalo pemmican to feed the hundreds of voyageurs who paddled the canoes. They established many of their fur outposts as much to gather buffalo meat as to gather furs; a factor's

GROUP OF BUFFALO AT EDGE OF A RIVER. John D. Howland, circa 1888. Oil on canvas. 17 x 22⅛ inches. Courtesy Amon Carter Museum, Fort Worth. *Howland was acclaimed for his many Western game portraits, particularly for the buffalo, one of his favorite subjects. And he had adequate chance to become familiar with them, for he left home at age fourteen to join the American Fur Company and worked for* Harper's Weekly *as a field correspondent.*

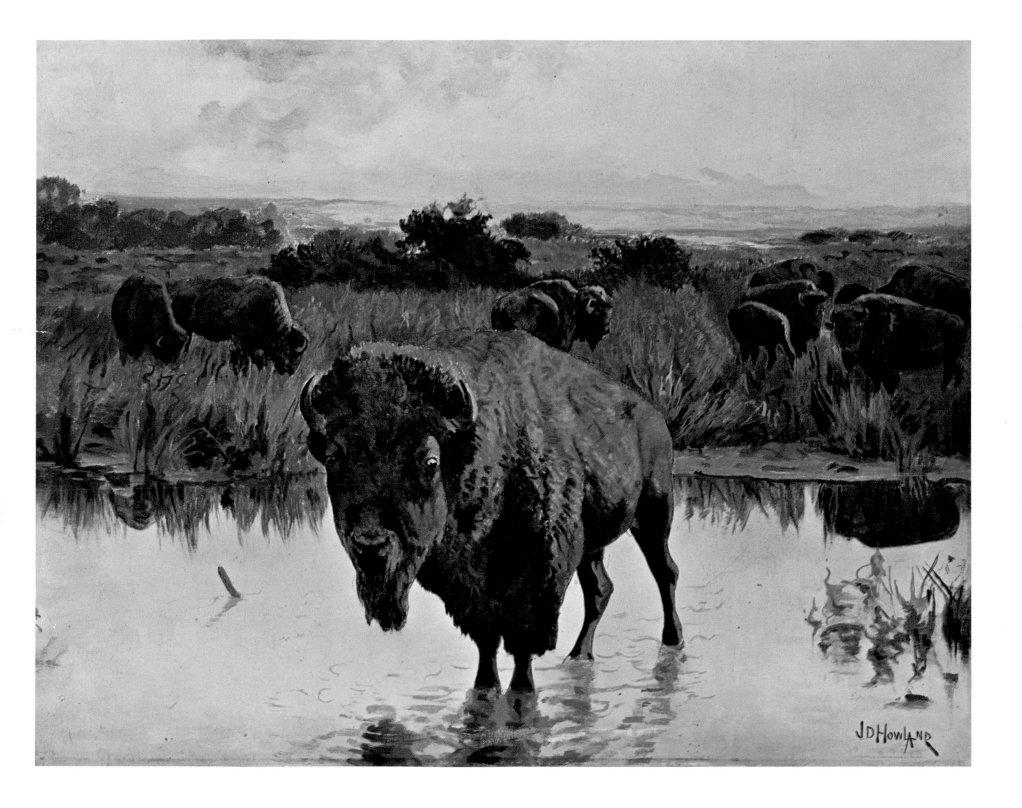

success at his job might depend upon his ability as a meat supplier. A "Pemmican War" between the two companies broke out because the North-West Company viewed the Red River Colony as a Hudson's Bay attempt to interfere with its buffalo supply.

The big companies of the United States, with the swift Missouri to ride, needed no pemmican depots, but each fur post employed hunters or traded for Indian-killed meat in order to feed their men. After the collapse of the beaver-pelt trade, the companies switched to trading for Indian-tanned buffalo robes, thus encouraging the native buffalo hunters to kill for hide alone. Hundreds of thousands of robes went downriver in the late 1830s and the 1840s. This business changed the pattern of Blackfeet life: since only the women could tan the robes, a man, to become wealthy, needed extra tanners in the family; he took on extra wives (heretofore, the Blackfeet had lived monogamously). The size of Blackfeet tipis grew accordingly. Such production-planning paid. Some Blackfeet families earned as much as two thousand dollars per year producing robes — far more than Eastern factory workers or farmers.

By the late 1830s Isaiah Gregg noted that the buffalo "are rarely seen within two hundred miles of the frontier." In the 1840s other observers noted the herds had "shrunk" to within the confines of the high plains. They seemed to think the herds had withdrawn from contact with encroaching settlers. Actually settlers had killed off local buffalo; the high plains observers saw buffalo that had traditionally occupied that region.

People thought of the buffalo as moving about far more than they actually did; some thought of them actually "emigrating" from south to north in the spring, back again in the fall, a several-thousand-mile trip each season — like seasonal bird flight. Buffalo do move about a lot, perhaps more so than other large game, but they don't migrate. Those living along the Milk River, in upper Missouri River country, may have tended to move north to the Bow River in the fall because the chinooks there made the winters milder; herds in the high country of Colorado may have moved a little south for the winter. But in the spring, neither the Missouri River nor Colorado herds tended to move back to the same country they'd vacated in the fall. They just wandered along, noses into the prevailing wind, searching for pasture and water, perhaps staying where they found it, perhaps wandering on. Buffalo move erratically, not in the migrations of folklore.

People believed much other buffalo folklore. Plainsmen held that when buffalo walked single file, each following animal stepped in the exact footprint of the one ahead. They claimed that the total buffalo population held at exactly 17 million; this number, they calculated, would exactly reproduce the herds each year. They told of a white, small buffalo that lived near Great Bear Lake River. They held that buffalo tunneled under the snow drifts and there, free from raging blizzard, peacefully cropped grass; that cows returned to the same place each year to bear their calves; that a swimming cow carried her calf on her back. None of it true.

The Indian peoples, too, developed a buffalo folklore. When buffalo had grazed nearby one day, only to disappear the next, they said they'd disappeared into a hole in the ground — that's where they'd originally come from. Back in the past, before the buffalo, a mean old lady had held the buffalo in a cave; Old Man had taken pity on the people, tricked the old lady and released the buffalo. Or, some said, the buffalo had all been held in a big sack, a sack that no one was to open more than four times; but luckily, one greedy fellow had opened it a fifth, and all the buffalo had escaped. In the winter, grandfathers told stories of gray ghost buffalo and stories of giant buffalo. They told stories of when buffalo ate men and how Old Man had put a stop to it by estab-

lishing a race between man and animals to decide whether buffalo should eat man or man eat buffalo. Man won. They told stories of magic buffalo who became men for awhile but could change back to being buffalo, stories of children raised by buffalo, who could speak to the buffalo, and always knew which buffalo to kill.

But they knew too much from observing actual buffalo to believe in tunnels under the snow or a swimming cow carrying a calf on her back.

Any Indian passerby dropped a feather, a bit of food, a claw — some gift to help assure good luck — beside certain buffalo-shaped rocks, jutting from the prairie. Buffalo-shaped pebbles or fossils could also bring good luck to the man who carried them.

The Indian hunter regarded the hunt as part religious undertaking, part excitement. He approached the hunt seriously, partaking of four prayerful rituals. A medicine man accompanied the hunting group and offered prayers and performed ceremonies as the hunt progressed. Following the hunt, offerings of bits of food and prayers thanked the buffalo for giving of his meat to people. The Cheyenne refrained from shouting in the excitement of the chase; to them it would have been sacrilegious.

The white hunter went out and shot meat and had done with it.

Both Indian and white often wasted meat. Either one might take only the tongue; often, from the 600-pound carcass they removed only the hump ribs, liver and upper gut. Both white and Indian sometimes downed several animals, just to choose the best.

The European immigrant found in America animals plentiful enough for the sport of shooting — and no game-keepers to keep out poachers, and game so abundant every man became a provider. He used any trick he could devise to ease his game-getting. He set snares and nets, jacklighted deer and speared fish under torchlight; clubbed swimming animals, set out saltblocks to entice them to ambush, and drove animals into swamps. He left little sport in hunting. He shot more than he could use and let it rot; he shot eagles just to see them fall. The plethora of game, the freedom from restraint in the New World led to wanton slaughter.

Colony government had attempted to restrain this as early as 1639 by passing game laws. Georgia passed a game law in 1759. Most all states had some game protection by the early nineteenth century — but not the federal government in its territories. Congress passed the first game law protecting the buffalo in 1855 in the wake of the many complaints about the slaughtering by Sir George Gore, who, in a splendiferous safari along the Platte and Missouri, killed 2,000 buffalo, 1,600 deer and elk and 105 bears, strewing the prairies with carrion. But in spite of a law on the books, all game kept right on disappearing; few people could see reason for restraint when any walk in the woods gave glimpses of game, when ducks blackened the sky each fall, when a man found himself driving through buffalo for days. They went right on slaughtering the buffalo even though men began warning early in the 1800s that the beast was disappearing. Artist George Catlin, returning from his half-year among the tribes of the upper Missouri — as remote a place as any on the continent, a place filled with buffalo — believed the buffalo would disappear in eight to ten years.

When the country east of the Mississippi no longer provided the bloody slaughter of the frontier experience, the American plinker took his guns to the West. Any trip onto the grasslands, to be complete, meant shooting a buffalo. The tenderfoot fretted until he entered buffalo country like a sailor who "cannot long more for land than the traveler in that region for buffalo." Eminent scientists and anthropologists succumbed to the itch. Lewis Henry Morgan could say

11

in his anthropological journal, "I have now seen and shot at buffalo until . . . I am quite satisfied." The Audubon party, on the upper Missouri, one day shot animals only because one of their party had not yet downed his bull. Along the Platte, a mighty hooraw arose whenever a wagon train sighted buffalo: "the drivers . . . would leave the teams and keep up a running fire after them . . . one . . . green horn . . . [chased] every buffalo that came along. . . ." Such goings on kept the herds so nervous many early wagon trains failed to see buffalo and shot no game. Indian tribes along the way attacked wagon trains as much for their wanton disturbance of their herds as any other reason.

The American millionaire and the titled European had a go at buffalo-plinking. They traveled in sumptuous style: champagne and wine at dinner, after-dinner brandy, tasty lunches served in the field on linen. The Army provided escorts and wagons (it gave the troops practice in the bivouac — said the officers — actually it gave them the chance to hobnob with bigwigs). Grand Duke Alexis of Russia celebrated his twenty-second birthday plinking at buffalo.

Buffalo outings became the rage. Even as the Atcheson, Topeka and Santa Fe Railroad was building into buffalo country it began running excursion trains of a weekend to allow the derbied a chance to do as the tophatted. As soon as the engine chuffed past a nearby herd, guns poked through raised windows and the plinking began — the shooting gallery of the county fair put on wheels. If the barrage should chance to down animals, the engineer obligingly stopped to allow the "hunters" to gather round the fallen: "then came the ladies; a ring was formed; the cornet band gathered around. . . ." Bigwigs from frontier towns aped the ways of millionaires — a vacation plinking at the buffalo became a must. One top-hatted old judge took his family onto the plains yearly to slaughter buffalo.

Others added to this slaughter. The Union Pacific and Santa Fe railroad builders fed the track layers on buffalo (until they almost revolted), the American Fur Company gathered thousands of buffalo robes, and, as the railroads pierced buffalo country, meat hunters shot buffalo for tongues to pickle and "hams" to smoke for the Eastern market.

Between 1830 and 1870 the buffalo population dropped from an estimated 30 million to an estimated 8 million, although, after 1855 the game law "protected" them.

If the government had wanted to protect the herds from the most wanton of this slaughter, it could have stopped excursion trains, limited meat and robe shipments, placed inspectors at important travel and trade centers. Congress had passed a law in 1855, but failed to implement it. Fur companies had opposed regulation; farmers could scarcely see themselves as neighbors to trampling herds; railroads, speculating in land sales to settlers, hardly wanted the herds nearby; almost no one lobbied for the buffalo in Washington, D.C.

And so matters stood when German tanners discovered a way to tan the buffalo hide into useful leather; heretofore manufacturers had found it too stretchable and soft to use in most of the usual leather creations. American tanners now began to use the German methods and, through advertisements appearing in the new railroad towns, offered to buy raw hides. Within a year the hide trade shipped far more hides East than did the robe trade (limited in output by its dependence upon tanning by Indian women).

Hide hunters could make as much as two dollars each for a good cow hide. Men laid off by a stoppage in railroad construction, as well as men who had been butchering buffalo to ship the meat east, formed groups to go among the herds and put the slaughter of buffalo on an organized basis. A small group used a hunter, a couple of skinners, and a camp rustler: the hunter owned the good gun (and, usually, the

other equipment) and shot each day's quota; the skinners removed the hides and loaded them in the wagon; the camp rustler cooked, pegged down and turned the hides as they dried, smoked hams, pickled tongues, piled and folded the cured hides. He rustled.

Somewhat wrongly these hide hunters have been blamed for the "extermination" of the buffalo. More accurate to say that they slaughtered the 8 million remaining of the 30 to 60 million buffalo alive in the 1500s; the other millions — hundreds of millions when one counts reproduction over three hundred years — disappeared because they made a nice target for thousands of bloodthirsty frontier plinkers. They disappeared at a rate of some one million per year from 1830 to 1870; they disappeared at about the same rate once the hide hunters went to work. By 1883 a thousand, perhaps two thousand, plains buffalo hid out in the remoteness of the Rocky Mountain states.

Now travelers throughout the grasslands, those who'd traveled amongst the buffalo millions, found the open spaces, once made somewhat friendly by buffalo presence, lonesome and dreary — empty as we see it today (where no cattle graze). Newcomers could yet tell that some big animal had lived here, his wallows dimpled the land and skeletons lay everywhere, many of them lying grouped where the hide hunter had slaughtered them.

Bone-picking became the last nineteenth-century money-making enterprise from buffalo. Homesteaders who found their acres littered with bones hauled them to the nearest railroad and received money from the first cash "crop." Others went into the "business" and did nothing else for several years but pick bones. Freighters, rather than make an empty trip one way, filled their wagons with bones as they traveled home. Red River carts of the Métis creaked and groaned along the Missouri and Red River, making bone trips where before they'd made yearly and even twice-yearly trips to gather meat for the Hudson's Bay Company. The bones went east in hundreds of trainloads, headed for sugar factories that used them in refining, to fertilizer factories and to china potteries. The easy pickings were through by 1890, but occasional boxcars of buffalo bones went east as late as the early 1900s. The land still showed the deep trails and the hundreds of wallows, hard-to-efface reminders of the buffalo.

In the three hundred and seventy years gone by since Cabeza de Vaca had walked amongst the herds from the Texas coast to Culiacan (and praised the taste of buffalo meat), men had wasted buffalo continually. Coronado's men slaughtered 500 animals as they prepared to march west from the false paradise of Quivara. A hundred years later sixteen Spaniards, traveling amongst the nomad buffalo hunters, joined in the slaughter with their arquebuses, killing 4,430 "beeves." About the same time, Father Hennepin, with La Salle, saw the Miamis kill 50 buffalo and take only the tongues. A hundred years later, in the Appalachians, an old man and his friends camped at a salt lick, killed 600 buffalo, then they left them to turn to carrion because the stench drove them away. Another hundred years and buffalo carcasses lay along the railroad tracks so thick one man believed he could have walked one hundred miles along the right-of-way and never have stepped from a carcass to the ground.

Today some twenty-five thousand buffalo graze in pastures scattered from coast to coast and in Hawaii, only a *pfft* away from extinction — but scattered enough to provide breeding stock against catastrophe. About half these thousands plod about the pastures of private owners, some of whom raise them because they feel an obligation to the beast, but most of whom raise them because nowadays you can sell buffalo meat at a profit. If business stays good, the herds may in-

13

crease; if the price drops the herds will decrease. Only the government herds here and in Canada (where some wood buffalo still exist) stand between them and obliteration.

This handful of buffalo lives today because, about 1900, several men saved even smaller handfuls: Buffalo Jones of Garden City, Kansas, who made four trips to Texas in the 1880s and captured fifty-six calves to start his herd; Charles Goodnight, eminent Texas rancher who raised buffalo from the 1880s until his death in 1929, founded a line that still exists in government herds in Moiese, Montana and Yellowstone Park (to name only two); Scotty Philip, who created a herd of several hundred in South Dakota about the turn of the century; Michel Pablo who raised buffalo in the country near Montana's Flathead Lake and sold them to the Canadian government to start a herd that now roams on the world's largest buffalo reserve, Wood Buffalo Park. These, and the holdings of a dozen or so other buffalo lovers — or, speculators, since they wore two hats — kept the turn-of-the-century buffalo census between one and two thousand and saved the beast for us today.

Much of the experimentation in trying to raise catalo, a cross between buffalo and domestic cattle, occurred in these herds, especially those of Buffalo Jones and Charles Goodnight. Each claimed to have created a crossed *fertile* animal, but each misinterpreted the facts before them. Only the later Canadian Wainwright experiment, using the animals produced by Canadian buffalo grower Mossom Boyd actually produced a fertile crossbreed — and this only at 31/32 cross in which all of the buffalo characteristics had disappeared. Today, some raisers produce a beefalo through artificial insemination; he, too, hardly resembles his forebears. The buffalo and domestic cow rarely cross, even though pastured together, but the effort to cross them goes back beyond Jones and Goodnight, to farmers of the eighteenth century in New Jersey and in Kentucky, where, early writers claim,

dairy farmers produced milk from such a cross, a milk more popular than that from domestic cows. And in Nebraska, during the nineteenth century, one man produced a popular cheese from such crossbred animals. But few modern ranchers raise crossbreeds; less glamorous breeds produce more milk and beef.

Sixty years ago, Americans expected to see buffalo meat in the butcher shop about Christmas time; for a day or so, the animal entire, hide and all, sprawled across the sawdust-covered floor, an exhibit sure to draw most of the town through the door. Yet the demand existed only for the holiday season; buffalo raisers could not sell enough to make it pay.

Now, in some city supermarkets, the meat sells year long at prices much higher than beef, a year-long specialty market. And some drive-ins sell buffalo-burgers. But most Americans do without, missing a delicacy that no other "wild" meat can provide — if one eats only the best cuts, the hump meat, the loin, the hindquarters, and the tongue. Buffalo meat, like most wild meat, provides protein with less fat and less cholesterol than our force-fed domestic animals.

Most of those who ate the meat as they crossed the plains a hundred years ago praised it, "And is such meat really good? . . . Ask a Catholic if he loves . . . The Virgin Mary." One soldier said buffalo meat "was tender enough to absorb through a straw." But it didn't please all palates; some found "very little does for me."

Often travelers ate juicy hump-rib they had roasted over a bed of glowing buffalo chip coals. On the treeless plains the chips lay everywhere; men had only to spear them with a ramrod as they walked near the wagons, now and then sliding a collection into a gunnysack that hung swaying beneath the wagon bed, fuel for tonight. When dry the chips flamed somewhat, puny flames that some people fed with buffalo tallow; when damp they smoldered and stank. But

14

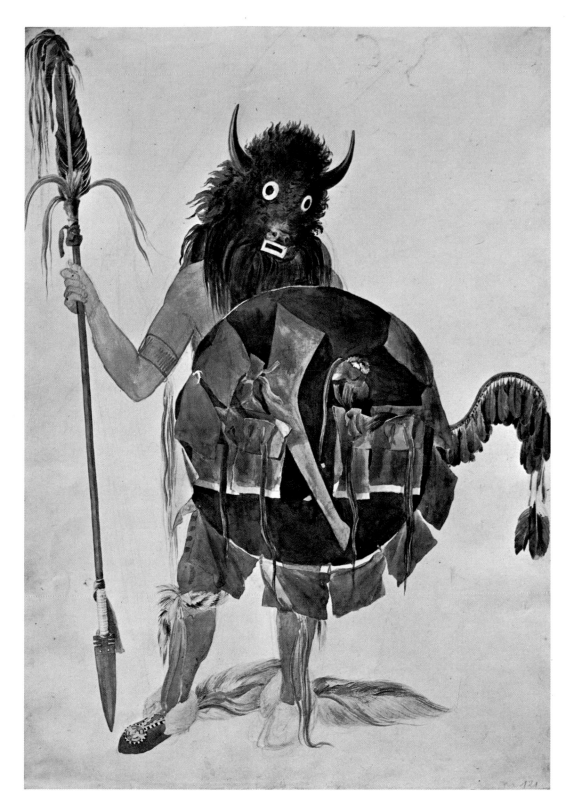

MANDAN BUFFALO DANCER. Karl Bodmer, circa 1833–1834. Watercolor on paper. 16⅞ x 11⅞ inches. Courtesy Northern Natural Gas Company Collection, Joslyn Art Museum, Omaha. *Maximilian's decision to winter at Fort Clark, near the Mandan Indian village of Mih-Tutta-Hang-Kush, was a provident one, for the tribe was virtually decimated by smallpox three years later. Bodmer's paintings are the most accurate pictorial record of these Indians extant. This sketch of a Mandan in the bison-dance costume shows all the significant details — the buffalo head mask, the spear and the shield, the body paint, and the buffalo hair anklets which imparted magic to the dance.*

they cooked food, and those who cooked over them joked that now you needed no salt and pepper.

Resourceful frontiersmen spread layers of chips under their beds on a cold night, creating inches of natural insulation — buffalo chips under them, buffalo robe over them, they slept warm. Similarly, they picked buffalo hair from bushes and stuffed it in moccasins and mittens for warmth. Sometimes the hide hunter piled chips to make a gun rest for his heavy .50 caliber Sharps. Coronado's men piled them as markers on their way to Quivara, creating guideposts for the return trip across the featureless plains. Indians used them as ceremonial resting places for their pipes; they lit the pipes with tinder of sacred, crumbled chip. On the plains, everyone used the chip imaginatively.

The most active thing in the placid routine of the buffalo year occurred when the animals coalesced in gigantic groupings during the summer rut — July, spilling over into June and August. During most of the year, a buffalo lived in a herd of about fifty to three hundred; now he entered a swarming that obliterated the old herd, a swarming that likely separated the adult bull or cow from previous companions forever. Only the cow and new calf, and perhaps her yearling and two-year-old, stayed together. In this way buffalo nature provided its own bars against inbreeding. This coalescing brought bulls and cows together from early June through September; during the rest of the year they tended to live bulls in their herds, cows in theirs, with some erratic intermingling, and some tendency for bulls, on occasion, to wander off alone or with a companion or two.

We could begin the buffalo year with the birthing of calves in the spring, an event that follows the rut by 275 days of gestation. The cow usually drops her calf in a spot secluded from the curious members of her herd. Within ninety minutes, after his first meal, the calf frolics about

her; within weeks he has developed enough speed to attempt to keep up with the herd on a short spurt, within six months he can outrun the big bulls (so slow they lumber in the wake of the swifter cows during any stampede).

The calf appears in the world minus the family hump, it begins to develop in about eight weeks; his color also differs; a yellowish cinnamon that begins to darken under the chin in four weeks, about the muzzle in eight weeks. He now seems dirty-faced.

The cow tries to wean the baby before the next one arrives, but often she has to nurse a year-old and a newborn offspring, for calves tend to stay with mother, the bull until he's four years old when he joins a bull group as a sub-dominant member, the heifer when she drops her first calf at about three years old. Both begin sprouting horns at about one month and have full-grown, black, sharp-pointed weapons in a year. The horns develop yearly; one can tell a buffalo's age somewhat by "annual rings."

Each spring, adult buffalo shed the hair they grew for the winter, a process that destroys their magnificent appearance of November. The rich, raisin-brown mane has bleached under snow, rain and sun to a peroxided tan. The body hair comes out in patches, making buffalo ragged, tatterdemalion creatures. As they move through brush, they leave behind a pre-leaf foliage on bare branches, a hair-lichen on the bark of trees they rub against. When the spring sun hits a herd just right, the old hair of their mane reflects metallically. Shedding, for some animals, goes on all summer; not until November do they appear as the magnificent Lord of the Prairies pictured in so many paintings.

In the herd, buffalo live in a shifting dominance pattern, each member automatically aware of his place in the pattern. A sub-dominant cow moves placidly out of a nice wallow at the approach of a dominant animal, a sub-dominant bull gives up his place in a trail, at a good feeding spot or at

a water hole if a dominant animal, cow or bull, approaches. This dominance pattern is established quietly: buffalo fight less than pictures might suggest, only an occasional horn waving or shoving amongst the cows or the bulls — except for occasional bull fights during the rut, and they involve mostly head-to-head, tremendous shovings (these noisy and dramatic encounters occur all but hidden in the raised dust). Each bull knows the damage a horn in the flank could do, knows the strength in his adversary's neck and shoulders; he could be lifted off his feet, tossed, disemboweled. In such matches, the seven- or eight-year-old, in his prime, weighing about eighteen hundred pounds, usually wins.

Few of these fights last more than seconds; they are contests of strength that leave an easy avenue of submission for the defeated. By disengaging horns and backing away, swinging his head in a "no," he ends the fight. In fact, often the fight never occurs; two bulls decide their differences over a cow in heat by a display of bluffing patterns.

The winner of the engagement, however, depends upon the cow's acquiescence before the sexual coupling can take place; his winning does not ensure mating. He may have to tend her for a day or two, chasing off all competitors before she accepts him, and in that time he may meet his better. He courts incessantly — he dare not leave off tending for fear this cow of the moment may accept another (the sexual bond occupies only a few seconds). He loses perhaps two hundred pounds, his bellow becomes hoarse, his great blue tongue hangs among the heads of grass; the cow retains her weight, and except for an occasional run from overly importunate suitors, remains far more placid than the bull.

Come October the bull has regained his weight and the animals have begun to split into bull and cow groupings for the winter. In the old days, both stayed fleshed during the winter months, but seemed too gaunt in the spring. Cows then lived more out on the open plain, sometimes staying

even during the blizzard; bulls (sensible males) preferred cover.

As the snow melted, the herds began to move, restless, searching for greening grass. Indians found spring hunting difficult, the cows (carrying the best meat) wary, guarding the calves, bulls, their meat more palatable than during the rest of the year, moving a lot. But a calf startled from his hiding place (one had almost to step on him to discover him or move him) often would follow a hunter home and become veal stew. The youngest calves could also be taken by running a herd; mother fled to save her own skin. The herd might also be run up banks too steep for baby to climb; mother rarely stayed to protect it. But harvesting the buffalo in the spring proved difficult. Most tribes found winter hunting easiest, contrary to what we would think, and what most paintings of buffalo hunting show.

Buffalo marked their territory as no other animal. Their habit of walking single file to water wore deep trails from distant hills to the closest streams. Such trails sometimes reached eighteen inches deep. Those that led into the Platte from north and south made wagon travel west a constant *kerchunk, kerchunk* that loosened felloes and broke axles — most knowledgeable forty-niners carried parts to repair such buffalo-induced damage. But the trails often served to indicate the easiest route over a ridge. Indians had used these ready-made trails long before the arrival of Europeans; some roads and railroads yet follow the path of early buffalo trails. But we mustn't think of buffalo as unerring road surveyors; most explorers found the trails too meandering to follow. The trails cut deep on slopes, or ridges or coulees, and in time created gullied washouts. The trails coming into high plains streams broke the deep banks down into gentle slope, creating easy fords.

Wallows on the level plains, some mere scuffed-out

places, some, in soft soil, a hundred feet in diameter, made further obstacles to wagon progress. In hilly country, the beasts preferred to wallow along the ridges, on the gentle slopes that provided a spot for an afternoon's sunning. This, of course, eroded the ridges and sidehills.

Spring expeditions onto the plains found wallows handy watering places for their mounts; wallows everywhere had collected the spring rain creating thousands of miniature oases, ringed by tall green grass, a gathering place for birds and small animals. But as June became July the oases began to stink either of their own stagnancy or of buffalo offal. Some became great loblollys of mud. By August most had dried completely and only buffalo used them, wallowing to fill their hair with dust, sending geysers of dust skyward. (Dust geysers arise continually from the grazing herd, sometimes each foot-plop making its own small eruption; somewhere in the herd, some animal is always enjoying a good wallow, if only going down on one knee to slither neck and side of face about before rising again.)

If a herd hung about a favorite watering hole for a time, they likely trampled the brush to bits, pushed over smaller trees as they rubbed, or debarked the larger trees at shoulder height. Such a laying waste no doubt gave birth to the myth that the buffalo cleared the plains of onetime forest cover. They did, for sure, knock down much of the man-made single file forest — the first telegraph poles. They proved such a nuisance one railroad company drove large spikes in the poles to discourage them, only to attract them the more by such back-scratcher protuberances.

Some large gathering places smelled bad from buffalo habitation — urine and droppings and the animal's own musk. A valley in Montana the Indians called Passamari (Stinkingwater) because of buffalo stench. Buffalo occupancy and the resulting middens created a lot of place names: the Hair Hills, Buffalo Gap, Pile of Bones Creek and the like. Buffalo droppings provided homes for millions of insects and fertilized the very ridges buffalo scarified; hundreds of birds fed on the insects; some birds followed the buffalo as he walked, feet dragging through grass, raising the insects; other birds sat upon his spine eating the insects that had meant to eat on him. Many birds used the shed hair clinging to thousands of branches to soften the nest, so did some burrowing animals. A great buffalo-created symbiosis existed.

We know what buffalo look like and we've seen Western scenery in hundreds of movies. If a man paints both, let him reveal to us something more than shapes and colors. Artist Rudolph Kurz's *Herd of Buffalo Fording a River*, emerging dripping from a swim, move as real buffalo in a real place; he's caught the snort of air through nostrils; the animals come at us at a moment when, unpredictably, they may charge, or change their minds and flee. John Howland's painting *Group of Buffalo at Edge of a River* catches buffalo enjoying a moment in a real Western environment. Here is an environment that all plains dwellers come to know — the sudden moisture after the dryness underfoot and the beat of sun on the head, the greenness and the cool shade scented by willow, animal musk, and manure.

We Americans hold hundreds of buffalo images in our heads, images arising from illustrations in adventure books, flickering images from Westerns, pictures hung in galleries. A few of the images have interpreted the nature of the buffalo, but many have repeatedly shown popular folklore, each consecutive artist embellishing previous buffalo pictures, using similarities in composition or even downright plagiarism of subject and form. Rindisbacher's *Blackfeet Hunting on Horseback* appears in several copies. Likewise, several buffalo "studies" look like Van der Schley's *Buffel*.

Indian drawings also tend to look alike — but for different

reasons. Indian women copied traditional symbolic buffalo designs as well as creating their own. Usually men drew "real" scenes; women created the abstract designs used for clothing or utensil decoration. For instance, the hourglass design, painted or done in quillwork and beadwork, was a standard symbol for buffalo among Comanche women; it is an abstract buffalo-hide shape. The real buffalo shape on the Brulé Sioux pipe bag is unusual.

Before the Indian man with the need to draw began to copy the "realism" of European drawing, he presented vital original interpretations of buffalo. Although his drawings of battles or hunts are sticklike, more symbolic than realistic, he undoubtedly saw the sketchy figures and abstract arrangement as real; the symbols created images in his mind as words do on paper.

Since most Indians painted on leather (using a spongy buffalo knee cap as a brush), much of it disappeared, rotted, or wore out. The paintings, after all, decorated such disposables as clothing, parfleches and tipis. Some tribes made new tipis each year; some men demanded two new robes each year. Also much buffalo drawing appeared on painted faces and bodies. It also appeared in the grass — see Catlin's *Medicine Buffalo of the Sioux* — or on bark. It was ephemeral, done to fit the occasion and forgotten, ritual painting, ceremonial painting, household and clothing decoration. How often they drew likenesses of buffalo, we don't know. When one searches through Indian artifacts he finds few drawings of buffalo; only seven per cent of known decorated buffalo robes carry drawings of buffalo. Some appear on drums.

The buffalo hunter scratched few buffalo likenesses into stone cliff faces, almost none in contrast to the thousands of sheep likenesses one finds. Today one finds few buffalo carvings among artifacts, although *iniskims*, natural stone or fossil, carrying buffalo-like humps are numerous enough.

Pictured in this volume are two excellent Indian-carved pieces, so well done, so abstractly presented they reveal much to us about the carver's vision of buffalo. But we see so few. If we have these, why not more?

We might say the Indian used real buffalo skulls so symbolically he neglected to draw skulls; he prayed to a skull when he emerged from the sweat lodge, he stuffed it symbolically for the sun dance, he used it magically to point the direction of a dream-invoked herd. Karl Bodmer shows us that he used heads and tails as dance costume. He saw buffalo and buffalo parts so symbolically, perhaps he felt no need to further portray him. Or, perhaps, like other magic-oriented men, he believed the picture might take the place of the game, that bad luck might follow the delineation of such a revered animal.

The Indian-drawn chase pictures on sketchbook and fan presented in this book make up a different kind of pictorialization, an attempt at a different kind of reality. The native artists drew these pictures after seeing the white man's sketchings, an operation that seemed magical and was regarded with awe and astonishment.

Most of the artists represented here saw living buffalo before the "extermination," some as frontiersmen, some as tourists. Looking at Albert Bierstadt's paintings one sees that his was the eye of the tourist; he came West to see the sights, and they duly impressed him. He painted the peaks and the sweeps, the clouds, the lights and shadows in magnificent renderings. Bierstadt made three Western trips to gather raw stuff for his stirring, enormous, grandiose landscapes. *Last of the Buffalo* was painted in 1888, twenty-five years after his second trip West. It provides excellent delineation of the melodrama of buffalo hunting; buffalo head into belly of the rearing white horse, Indian rider with spear raised.

Alfred Jacob Miller painted souvenirs of the West for

Murthly Castle, Captain William Drummond Stewart's home in Scotland, which show glimpses of trapper doings and Indian doings in primeval landscapes. He drew delightfully, with affection and admiration for his subjects. In *Taking the Hump Rib* he accurately preserved a Western scene. Indians usually opened the buffalo carcass from the top. They wanted the robe in two halves, but more especially, the prime meat lay along the spine, the hump ribs, the backfat and the *dépouille*. Trappers called it frontier bread for it was served with almost every meal; it lay in long strips on each side of the spine. The Indian, butchering from along the spine, reached the choice innards by breaking some ribs to reach in for the liver and the upper gut.

Miller allows us to join scenes in the trapper's Eden. His is the romantic West, not in terms of the unreal, but in terms of the way the men he traveled with saw themselves and their country. His delicate scenes and almost mythological horses and heroic men might make figures in a Western tapestry. Yet his big buffalo relate to "making meat." He paints them as the trapper and explorer saw them, target and food.

Another tourist, George Catlin, had decided in 1832 that he would devote his life "to the production of a literal and graphic delineation of the living manners, customs and character of an interesting race of people, who are rapidly passing away from the face of the earth." In documenting the life of Indian tribes of the upper Missouri River, he became involved with the buffalo and proclaimed, "Nature has nowhere presented . . . of *man* and *beast*, no nobler specimens than those who inhabit them [Western scenes] — the *Indian* and the *buffalo* — joint and original tenants of the soil. . . ."

Eyes, horns, hump, shaggy mane and tail, that's what all the artists drew; but Catlin drew differently. His buffalo seems a strange, comic, bewildered personality caught in a giant's frame, with strength that he uses only in moments of frustration or retaliation. "Leave me alone" his baffled anger seems to say, as he stares at us in *Buffalo Bull Grazing*. Catlin focused on the animal's nature, *its* viewpoint rather than man's.

Catlin's buffalo show more of buffalo nature than do the buffalo presented by the illustrator. In order to catch the eye of the *Harper's Weekly* subscriber or the buyer of chromos, this Western visitor often used the buffalo to feed the adventurous moment. Through his eyes we see the barrages shot from guns aimed through railway train windows; the strangely amazing sight of a draped carriage in the midst of a buffalo hunt; a lady shootist among the herds; or the hide hunter holding the hide above a stripped carcass. Instructive melodrama designed by Frenzeny and Tavernier to stir us against the waste and brutality of hide gathering.

The sketches of the field illustrator were often edited by a second hand — that of the engraver — and many scenes lost some of their documentary immediacy through the crudeness of the medium by which they were reproduced. For realism, we turn to the work of the frontier photographer. Look at the woman trundling the wheelbarrow of buffalo chips. Somehow, none of the early diaries or memoirs quite prepare us for this stark image of pioneer life on the plains. L. A. Huffman's photo of slain buffalo awakens us also. These bodies seem to have shrunk in death, and they lie in the snow so much more limply than in paintings.

In the work of the untrained artist we also see powerful

YELL OF TRIUMPH. Alfred Jacob Miller, circa 1858. Watercolor on paper. 8⅛ x 12⅜ inches. Courtesy The Walters Art Gallery, Baltimore. *The ebullient scene of victory after successfully running the buffalo, in which the Indian hunters yelled and sang praises to the spirit of their prey, is the subject of Miller's attention here.*

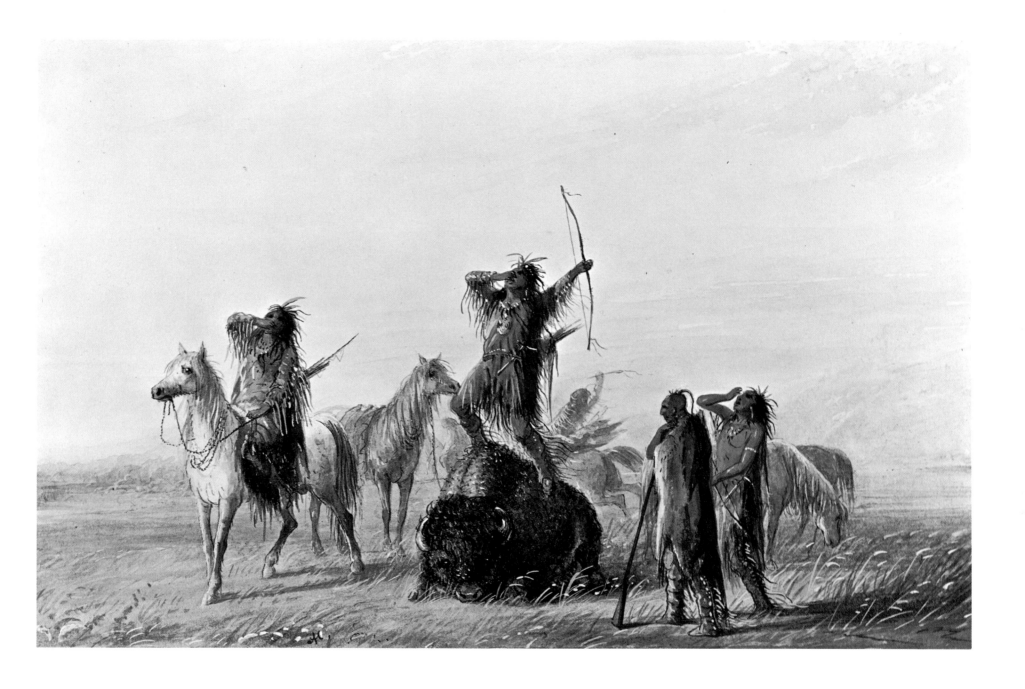

21

moments of frozen reality. Although the buffalo heads are swollen, the tracks in the snow unreal, and the wolves strangely foxlike in the unknown artist's painting of two buffalo at bay, the eye senses real recall here and a desire to put it down right. The two stand in loneness, left behind by the disappearing herd. The fight goes on in a natural place, not a luminous magicland. L. W. Aldrich's primitive painting of the buffalo chase retains much of the excitement a rider must have felt as he rode at full gallop amongst beasts that outweighed him and his horse together. He, as most depicters of the chase, fails to show the cloud of dust that rose from all of those thundering hooves, a cloud that most riders said blinded them so they found a buffalo to shoot mostly by chance. If they were lucky, a big buffalo target would loom up next to them giving them a chance to shoot. But Aldrich's outstretched horses contain the frenzy of buffalo horses that would jump twenty feet to join the chase, horses that, left behind when others went to the chase, might break their tethers and join in just for their love of it.

Little of this frenzied kind of horse nature appears in other paintings of the chase, except perhaps in Charles Russell's *Buffalo Hunt No. 39*. Here melodramatic occasion and buffalo nature meld. The head caught over another's spine, the concentration of the cow on her frightened calf, the uncoordinated milling create an energy that draws us into the buffalo hunt of almost a hundred years ago as few other paintings do. Charlie has even allowed some dust to arise.

Yet, there's some folklore in Charlie's painting of the fight between buffalo and grizzly bear as it implies that they fought often. They had little need to battle unless a hungry bear came upon a decrepit buffalo ripe for destruction.

But folklore and the painting of buffalo go hand in hand. We see this especially in the early European drawings of the beast, in which Spaniard and Frenchman draw somewhat buffalo-shaped animals that seem to have sprung from a medieval bestiary. Perhaps they tried to follow some of the early descriptions that arrived in Europe: "a horsemane upon their backbone," a tufted, lion-like tail, "their beard is like that of a goat's," a tail "carried like a scorpion's" when they ran. They knew little of natural history and believed in monsters; the new country had furnished them with rattlesnakes, armadillos, and opossums to make them believe in them further. The buffalo with the bouffant hairdo is not so *outré*. I saw a head just like it at a recent buffalo sale.

Few painters have convinced us entirely of the fact of the buffalo millions; somehow we can't experience it in a painting. Hays's *The Herd on the Move* comes close. The buffalo cover the hills as in the Indian description, "the country was one robe." Catlin's *Buffalo Herds Crossing the Upper Missouri* helps us to see the nuisance of the erratic hordes and to a degree gives a feel for their numbers. Probably the difficulty lies in being a stationary viewer. Those who wrote in awe of the millions moved through the bodies for days. Perhaps no painter or photographer could do complete justice to that experience, for it stopped words. Most men could describe it only in hours it took them to move through the masses, with some attention to the dust raised and the musky smell: "For five days we had ridden through . . . a mobile sea of buffalo." One Spaniard dared estimate numbers only because other witnesses were still alive and could back him up.

Most everyone who took to buffalo country wrote home about the buffalo they saw, for the stay-at-homes wanted to know of buffalo. The conquistador, Captain Vicente de Zaldivar, wrote, "Its shape and form are so marvelous and laughable or frightful, that the more one sees it the more one desires to see it, and no one could be so melancholy that if he were to see it a hundred times a day he could keep from laughing heartily at it many times, or could fail to marvel at the sight of so ferocious an animal."

22

As we look at these pictures, we join with the frontier sketchers and writers who looked at buffalo curiously; we look with those who have always stopped their doings to have a look at buffalo doings. We become a part of the trapper congregation that in 1835 on the Teton deserted the Reverend Samuel Parker's sermon when someone shouted, "Buffalo nigh."

General Don Francisco Vasquez de Coronado, traveling through the Rio Grande country before he came to the buffalo plains, came across natives wearing large, brown, animal robes. At the pueblo of Hawikuh he inquired about the animal; the Indians showed him raw hides they had gathered. Still Coronado could not grasp what the animal looked like. Then one of the chiefs sent for a man. He came and stood before the Spaniard. The chief turned the man around to reveal, on the naked skin, the tattooed likeness of a buffalo. Coronado understood something of the beast from the picture.

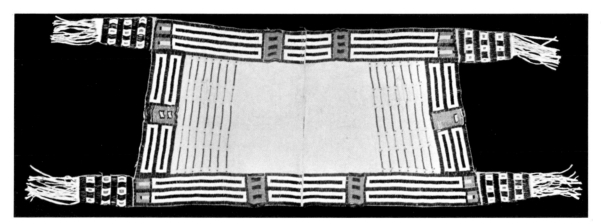

BEADED SADDLE BLANKET. Cheyenne, circa 1850. Leather and beadwork. 49¼ x 24½ inches. Courtesy Denver Art Museum. *Although many Indians rode bareback, especially in battle or when running buffalo, saddles were sometimes used. Women rode astride on a Spanish type, high-bowed saddle, while men rode on a less exaggerated tree or a soft-padded saddle stuffed with buffalo hair and grass. This beaded saddle blanket went under the saddle for ceremonial occasions.*

Sacred Gift to the Indian

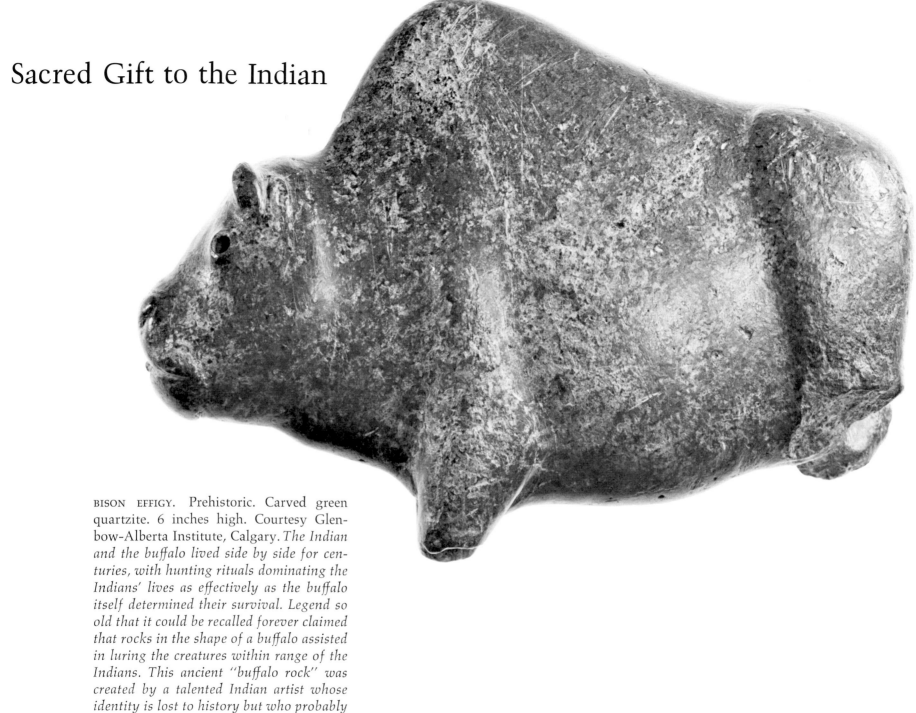

BISON EFFIGY. Prehistoric. Carved green quartzite. 6 inches high. Courtesy Glenbow-Alberta Institute, Calgary. *The Indian and the buffalo lived side by side for centuries, with hunting rituals dominating the Indians' lives as effectively as the buffalo itself determined their survival. Legend so old that it could be recalled forever claimed that rocks in the shape of a buffalo assisted in luring the creatures within range of the Indians. This ancient "buffalo rock" was created by a talented Indian artist whose identity is lost to history but who probably hoped to inspire a successful hunt with his work.*

25

QUIVER, BOW CASE, BOW AND ARROWS. Cheyenne, circa 1860. Beaded leather. Quiver 36½ inches long. Bow case 50¾ inches long. Courtesy Denver Art Museum. *The primary weapon of attack for the Indians was the bow and arrow. They could, of course, kill the buffalo with a lance, but once the Indians were mounted on the horse, they became much more effective with the bow and arrow.*

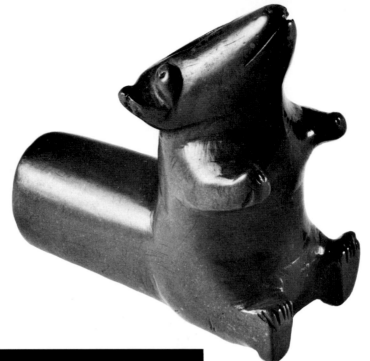

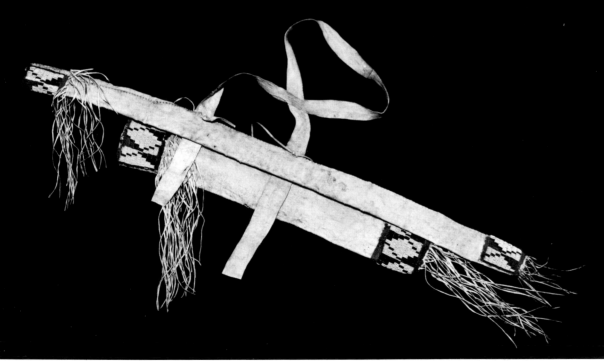

PIPE CARVED IN THE SHAPE OF A BUFFALO CALF. Sioux, circa 1870. Catlinite pipe bowl: 3 inches high x 2¾ inches wide. Courtesy Denver Art Museum. *A particular red claystone of southwestern Minnesota was dug for centuries by native Americans before the quarry was visited by the artist George Catlin in 1837. The mineral was scientifically recorded and subsequently named for him. The quarry, though held by the Sioux, was regarded with superstitious reverence and was a common ground from which all tribes could obtain this material for their sacred pipes.*

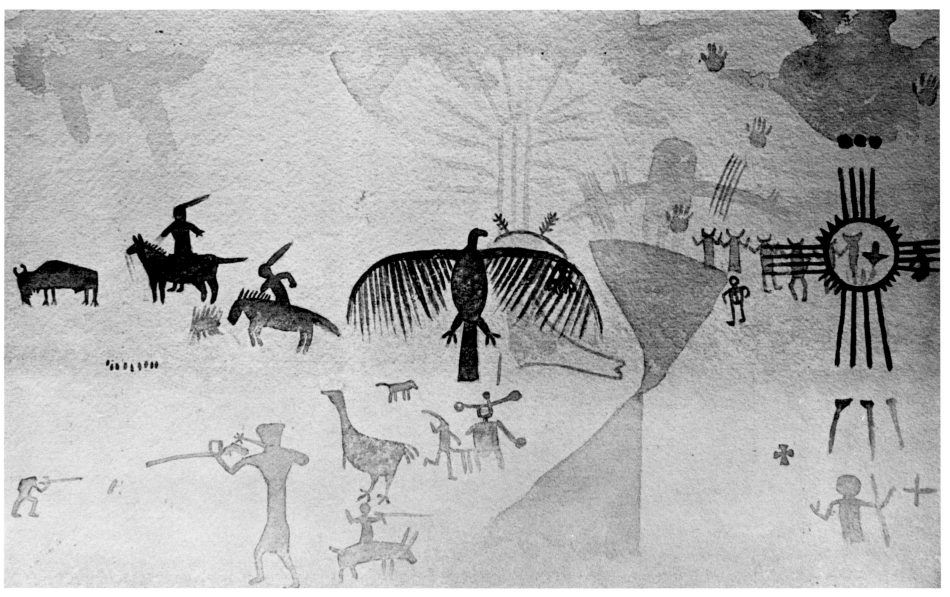

PICTOGRAPH AT MEYERS SPRINGS, TEXAS. Copied July 24, 1935, by Forrest Kirkland. Nineteenth century. Watercolor. 10⅞ x 15 inches. Courtesy Texas Memorial Museum, Austin. *The buffalo dominated Plains Indian life as few other animals have dominated a culture. The Indians literally worshipped him. They carved his image and lived in, ate, and walked on parts of his body. They held ceremonies to honor him, to attract him. And they painted his picture, as seen in this West Texas pictograph. The two purple red horses and riders in the left center seem to be engaged in the hunt.*

SIA BUFFALO MASK. Edward S. Curtis, 1926.
Photogravure. 15⅜ x 11½ inches. Cour-
tesy Amon Carter Museum, Fort Worth.
*Headdresses of buffalo hair and horns are
required for the buffalo dance as practiced
by several Plains and Southwestern tribes.
It is a strenuous dance in which the move-
ments and actions of the buffalo are realis-
tically imitated and readily comprehended
by the spectators.*

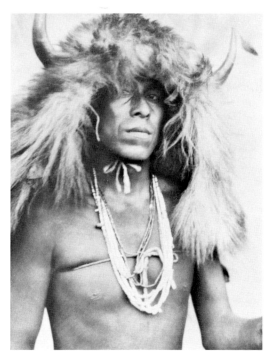

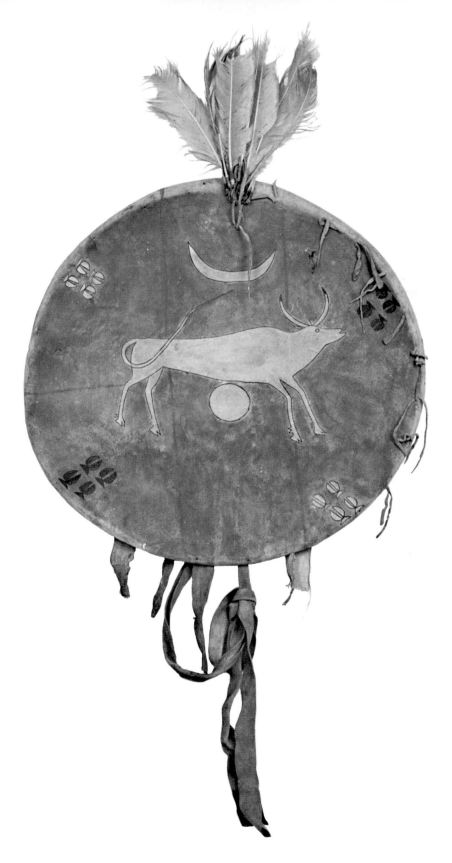

28

BUFFALO SHIELD. Cheyenne, after 1850. Painted cowhide and deerskin, stroud cloth, feathers. 18½ inches diameter. Courtesy Denver Art Museum. *The shield was the Plains warrior's most sacred possession. He received his first after proving himself in battle and was buried with his last. Its decoration and associated taboos and ritual care were revealed in a dream to a medicine man or tribal shield maker when the warrior commissioned its manufacture. The special medicine design which evoked the spiritual protection of the totem depicted was kept hidden by a shield cover and was revealed only in battle.*

GROS VENTRE HEADDRESS. 1850–1860. Buffalo skin and horns, braided horsehair, eagle feathers and talons. 40 inches long. Courtesy Buffalo Bill Historical Center, Cody, Wyoming. *This headdress was probably used as a part of the costume for the buffalo dance, a ceremony in which two young men with these headdresses and a young woman with the usual female attire plus a pair of smaller horns simulate the movements of the buffalo.*

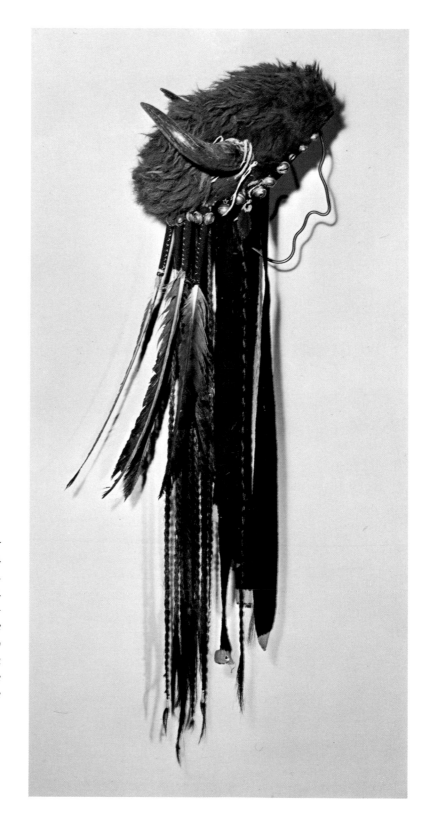

BUFFALO BONE PAINT BRUSHES. Sioux, circa 1850. Buffalo bone. Circa 3 inches long. Courtesy Denver Art Museum. *The Indians used the soft humerous bone as a paint brush. The yellow bone was used to apply the rare "gallstone yellow" color, made from the gallstone of the buffalo.*

HIDE SCRAPER. Ponca, circa 1850. Elkhorn. 13 inch handle, 5 inch crook. Courtesy Denver Art Museum. *This scraper, with the tally marks on the handle indicating the number of hides tanned, was used in the manner demonstrated in the photograph on page 36.*

A BLACKFOOT TRAVOIS. Edward S. Curtis, 1926. Photogravure. 11½ x 15⅝ inches. Courtesy Amon Carter Museum, Fort Worth. *The Plains Indian did not regard the frequent moving of his campsite in pursuit of the migrating buffalo with reluctance. Rather, it was a time of anticipation for greater abundance in a new environment. The tipi covers were folded into compact bundles and fastened to litters constructed from the tipi poles. Household goods, children, the sick, and the aged were then piled on to the capacity of the horse or dog which would drag the load to the new camp. This was the travois, so named by the French Canadians indicating the shafts by which the vehicle was pulled.*

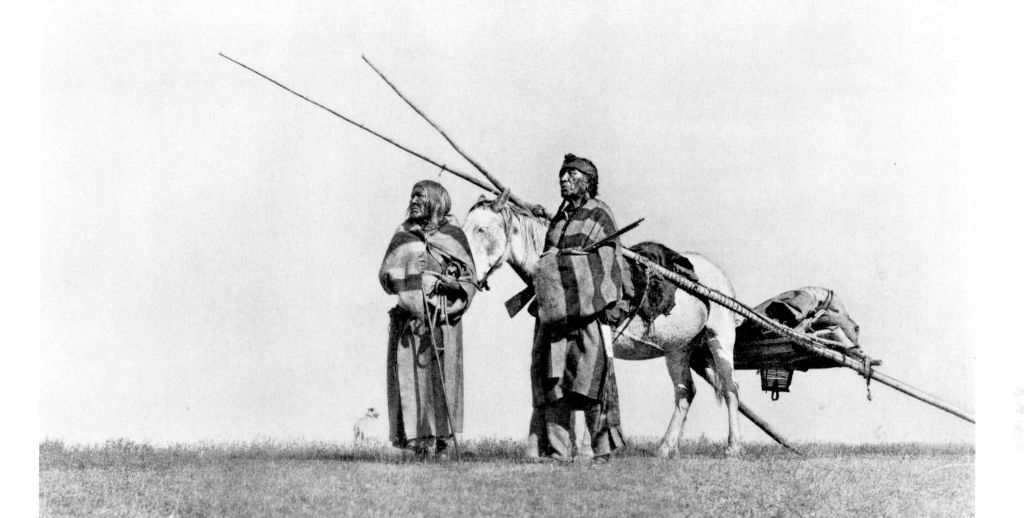

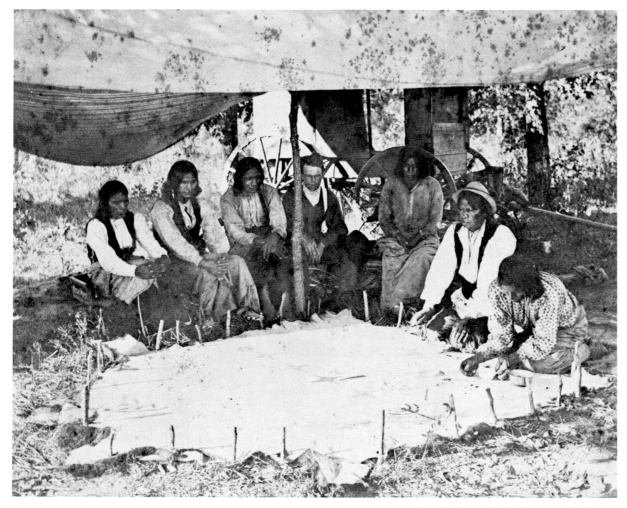

A PAINTED TIPI — ASSINIBOIN. Edward S. Curtis, 1926. Photogravure. 11⅜ x 15½ inches. Courtesy Amon Carter Museum, Fort Worth. *Buffalo hide tipis were often painted with symbols commemorative of a dream experienced by their owners and, thus, were cherished possessions, but were easily saleable when, after a few years according to custom, the owners disposed of them.*

COMANCHE AND KIOWA INDIANS PAINTING A BUFFALO ROBE. 1875. Photographic print made from the original print. Courtesy Oklahoma Historical Society, Oklahoma City. *With the buffalo hide stretched out and staked to the ground, these Comanche and Kiowa Indians are painting scenes from their history.*

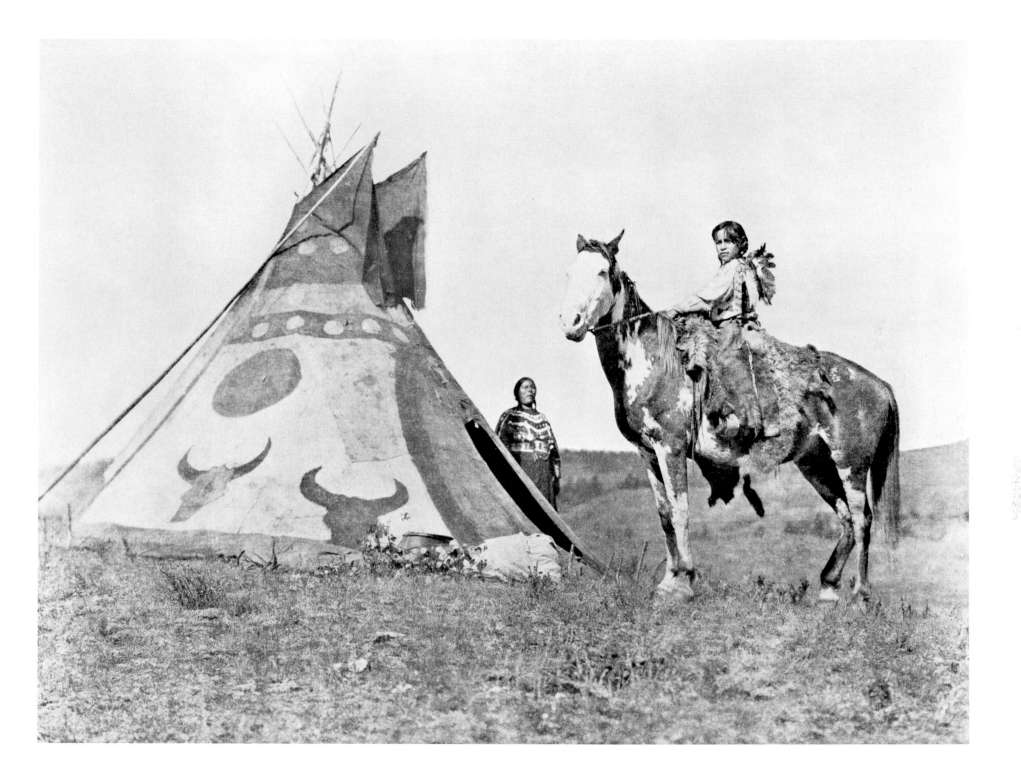

BEADED PIPE BAG. Brulé Sioux, 1870–1890. Buckskin with quill work. 37 x 7 inches. Courtesy Buffalo Bill Historical Center, Cody, Wyoming. *Ceremonial pipes were accorded special tribal veneration and care. They were tended by an appointed custodian, housed in a special tipi, and kept in elaborately decorated bags. This bag is decorated with a buffalo design embroidered with dyed porcupine quills.*

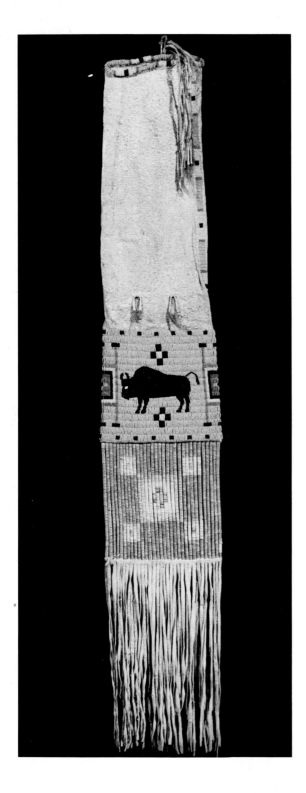

BUFFALO HORN SPOON. Blackfoot, circa 1850. Buffalo horn. 8¾ inches long x 2⅝ inches wide. Courtesy Denver Art Museum. *"The spoons which they eat with, do generally hold half a pint; and they laugh at the English for using small ones . . ." So reported Robert Beverly traveling in frontier Virginia in 1722. Spoons were made of pottery, wood, shell, gourd, whatever was adaptable in the local environment. Horn spoons such as this one were carved, then bent into shape by heating.*

PAINTED BUFFALO HIDE. Montana Sioux, circa 1850. Painted hide. Circa 84 x 87 inches. Courtesy Cincinnati Art Museum. *The Sioux decorated their buffalo robes with all kinds of symbols, including, of course, the bison. This robe was once the property of Standing Buffalo, a Sioux chief. It depicts the significant events in his life. It was acquired by General M. F. Force from Governor Benjamin Potts, of Montana Territory, in 1871.*

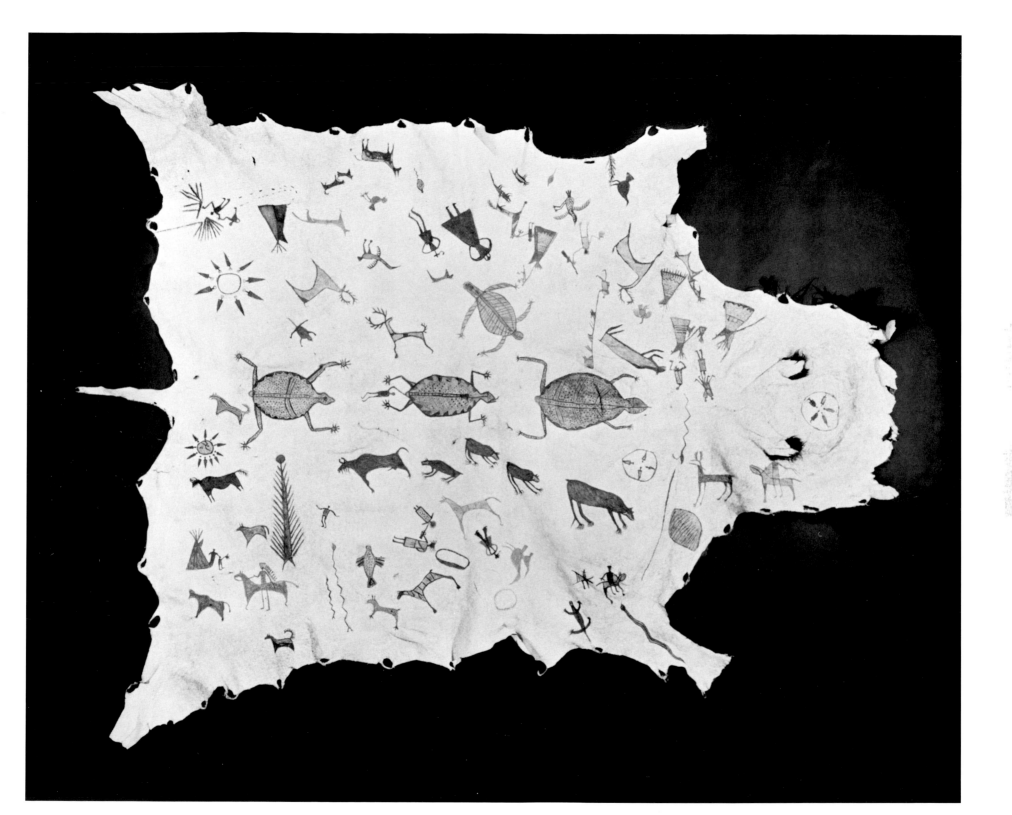

BUFFALO TOOTH AND TRADE BEAD NECKLACE.
Sioux, circa 1900. Buffalo teeth, white
glass beads. 24⅜ inches long. Courtesy
Denver Art Museum. *Various parts of the
buffalo were frequently used as decoration
or jewelry. This is a relatively late item,
however, combined with glass trade beads.*

FLESHING A HIDE — BLACKFOOT. Edward S.
Curtis, 1926. Photogravure. 11⅝ x 15½
inches. Courtesy Amon Carter Museum,
Fort Worth. *A long bone with a beveled
scraping edge was used for removing flesh
and fat from a hide. The thong, tied to the
woman's wrist, provided extra leverage.*

36

BISON PIPE. Cheyenne, n.d. Black stone pipe bowl. 4⅜ inches high x 7½ inches long x 1¼ inches wide. Courtesy Amon Carter Museum, Fort Worth. Gift of Arthur Woodward, Patagonia, Arizona. *The tobacco pipe and its use for pleasure, cure, and ceremony originated with the American Indian. The pipe's shape, decoration, and material differed according to locality and tribe. The unknown Cheyenne artisan's use of the buffalo form for this pipe bowl might have had ceremonial as well as decorative significance, for the smoking of special pipes was an important part of many religious and political occasions.*

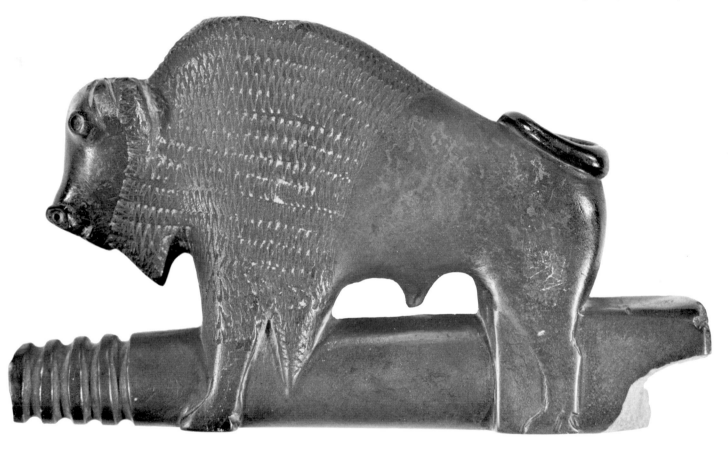

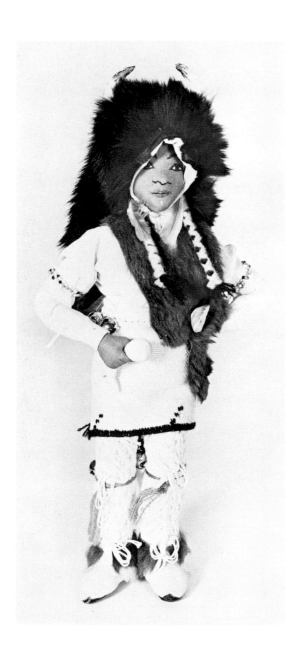

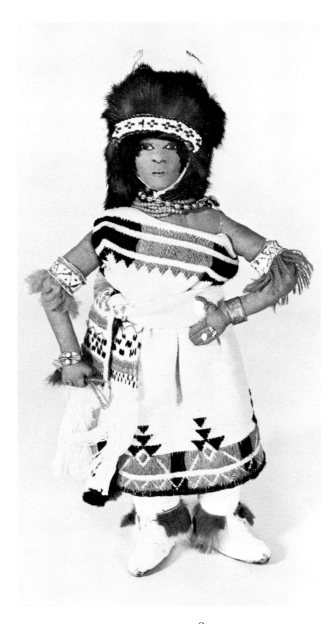

SAN JUAN MALE BUFFALO DANCER DOLL. (left) Circa 1941. Stuffed cloth, fur, yarn, beads, string, shell, thread, bells, and feathers. 14 inches high. Courtesy Taylor Museum of the Colorado Springs Fine Arts Center. *Made in the traditional manner for the Pueblo Indian Arts and Crafts Market, this doll represents the male dancer in the buffalo dance. (See Sia Buffalo Mask, page 28, and Gros Ventre Headdress, page 29.)*

SAN JUAN FEMALE BUFFALO DANCER DOLL. (right) Circa 1941. Stuffed cloth, fur, yarn, beads, string, thread, leather, feathers, and "silver." 13 inches high. Courtesy Taylor Museum of the Colorado Springs Fine Arts Center.

MAN'S SHIRT. Comanche, circa 1880. Leather with gallstone yellow paint. Shoulder width: 22¼ inches. Front length: 26½ inches. Back length: 30 inches. Courtesy Denver Art Museum. *A breech cloth and buffalo robe constituted the everyday costume of a Comanche brave. A decorated shirt of buffalo hide such as this would be preserved for ceremonial occasions. The fashion was probably copied from more northern tribes.*

European Visions

AMPLISSIMAE REGIONIS MISSISSIPPI [The Mississippi Valley]. G. Delisle, circa 1720. Engraving (hand-colored). 19 x 23 inches. Courtesy Mrs. Jenkins Garrett Collection, Fort Worth. *This map, engraved in Nuremberg by Homann, is one of the best of the American heartland for its period. It contains the routes of DeSoto, LaSalle, Tonti, Hennepin, and St. Denis, and has two beautifully done cartouches.*

[American Buffalo.] In Francisco López de Gomara, *La historia general de las Indias* (second edition, 1554). Woodcut. 2¼ x 2½ inches. Courtesy DeGolyer Library, Southern Methodist University, Dallas. *Possibly the first view Europeans had of an American bison, drawn by an artist who had never seen the creature himself. Probably done from one of the descriptions sent back to Spain by early adventurers in America.*

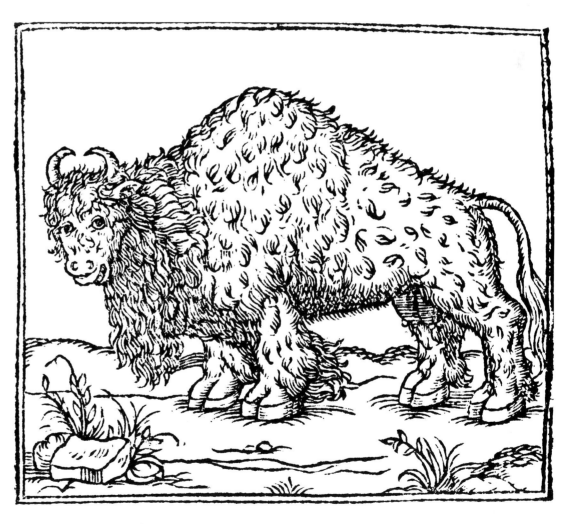

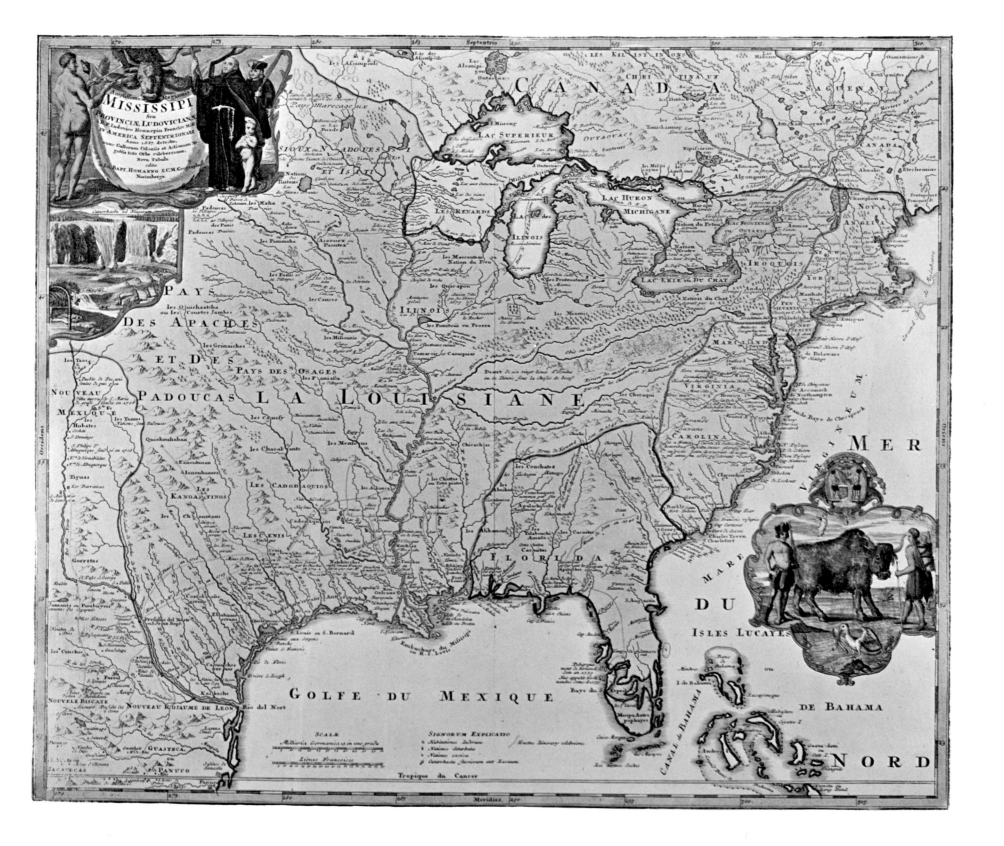

BUFFEL. Jacob van der Schley, circa 1770. Engraving. 10 x 14¼ inches. Courtesy Amon Carter Museum, Fort Worth. *Another image done by an artist who had little real acquaintance with America or the* bison. *Van der Schley was born in Amsterdam in 1715, gained a reputation as an illustrator and an engraver, and died in 1779.*

42

BOEUF DE LA NOUVELLE FRANCE. After Hennepin, circa 1775. Etching. 10½ x 7¼ inches. Courtesy Amon Carter Museum, Fort Worth. *The bison was becoming more domesticated, at least in the mind of this French artist.*

THE BUFFALLO. In *The Massachusetts Magazine*, April, 1792. Engraving. 5 x 8⅞ inches. Courtesy Amon Carter Museum, Fort Worth. *Although this portrait of a bison looks undeniably like a monkey, the writer for* The Massachusetts Magazine *claimed that he was "larger than an ox, has short black horns, with a large beard under his chin, and his head is so full of hair, that it falls over his eyes and gives him a frightful look." "The flesh of the Buffalo is excellent food, its hide extremely useful, and the hair very proper for the manufacture of various articles," the writer concluded.*

Maffa. Mag. NºIV. Vol. IV.

The BUFFALLO.

THE AMERICAN BISON. Iple, 1796. Engraving (hand-colored). 5¼ x 8½ inches. Courtesy Amon Carter Museum, Fort Worth. *The body has assumed a more familiar shape in this print, but the face appears more devilish than the bison would normally appear.*

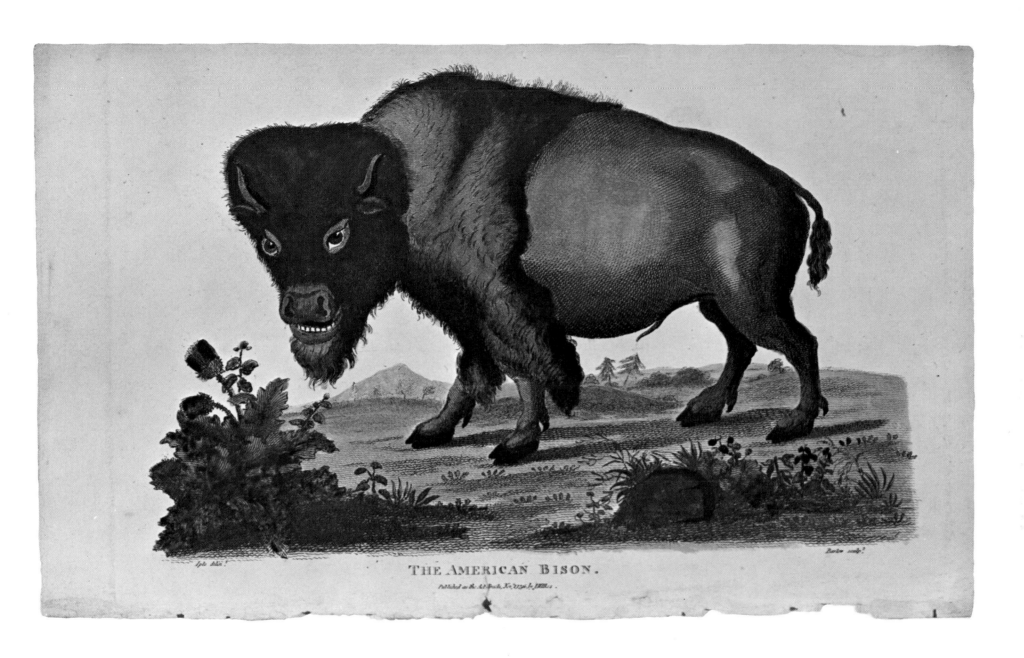

THE AMERICAN BISON.

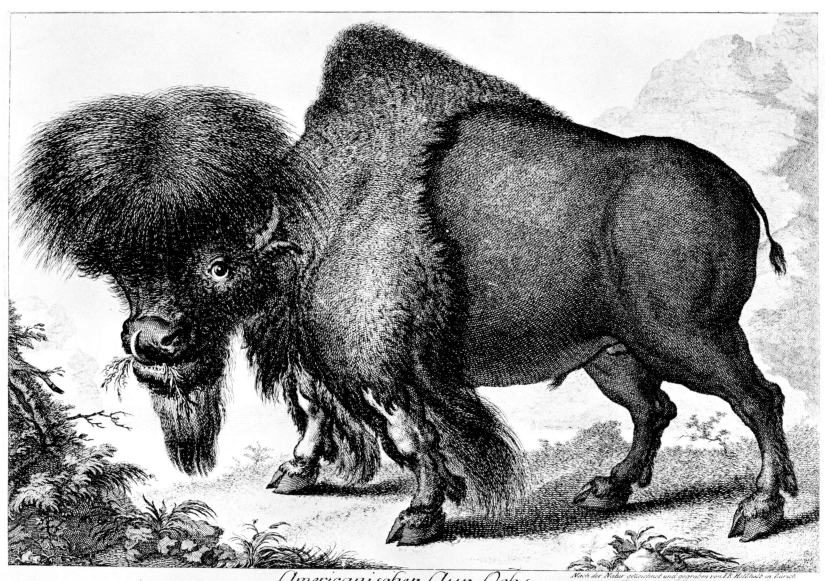

Americanischer Aur-Ochs.

BOS BISON.—*Bos Cornibus divaricatis, Juba longissima, Dorso gibboso.* Syst. Nat. 15. N.º 3. Lin.
Die Wilden in Nord-America nennen dieses Thier Mithihihsa.

46

AMERICANISCHER AUR-OCHS. BOS BISON . . .
Johann-Rudolph Holzhalb, 1790. Etching.
10¼ x 14¼ inches. Courtesy Amon Carter
Museum, Fort Worth. *Just as Europeans
romanticized the Native Americans, Holz-
halb, a Swiss engraver who died in 1806,
romanticized the bison.*

BISON BY ACACIA TREE. Mark Catesby,
1754. Engraving (hand-colored). 19⅝ x
13¾ inches. Courtesy Amon Carter Mu-
seum, Fort Worth. *Born in England in
1679, Catesby visited America in 1712 re-
maining for seven years, studying the bot-
any of the country. Upon his return to
England in 1726, he began engraving
plates for his* The Natural History of Caro-
lina, Florida, and the Bahama Islands. *He
might have seen a buffalo in the New
World, from which he made this print.*

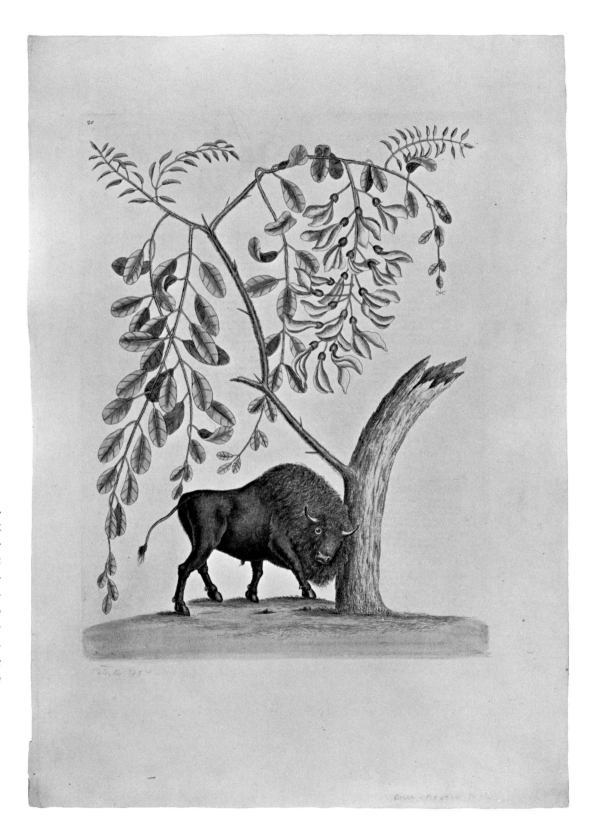

The Age of the Buffalo

BUFFALO HERDS ON THE UPPER MISSOURI. Karl Bodmer, 1833–1834. Watercolor on paper. 9⅝ x 12¼ inches. Courtesy Northern Natural Gas Company Collection, Joslyn Art Museum, Omaha. *When Prince Maximilian of Wied-Neuwied followed Catlin's route up the Missouri River, he took Swiss artist Karl Bodmer with him to do illustrations for the book that Maximilian intended to write. Maximilian pressed on past Fort Union to Fort McKenzie, on the mouth of the Marias River, the most remote American Fur Company post. On their return they saw these buffalo herds descending to drink, and Bodmer produced this pastoral delight.*

A BUFFALO POUND. FEB. 8, 1820. George Back, 1823. Engraving (hand-colored). Composition: 5⅜ x 8 inches. Courtesy Amon Carter Museum, Fort Worth. *A British naval lieutenant on Sir John Franklin's expedition, Back journeyed from Hudson Bay to the Canadian Arctic from 1818 to 1822 in search of a Northwest Passage. This engraving, published with Franklin's account of the trip, depicts the Indian method of luring the buffaloes into a corral-like enclosure for easy slaughter.*

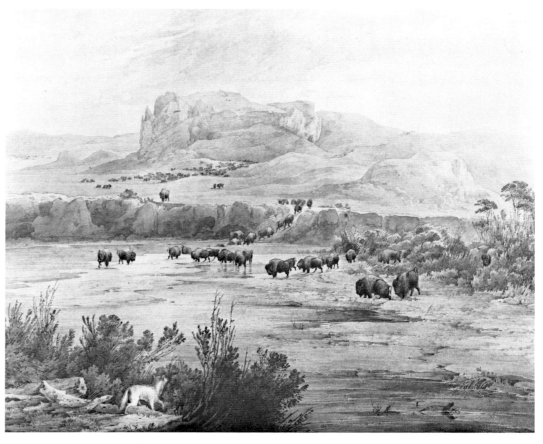

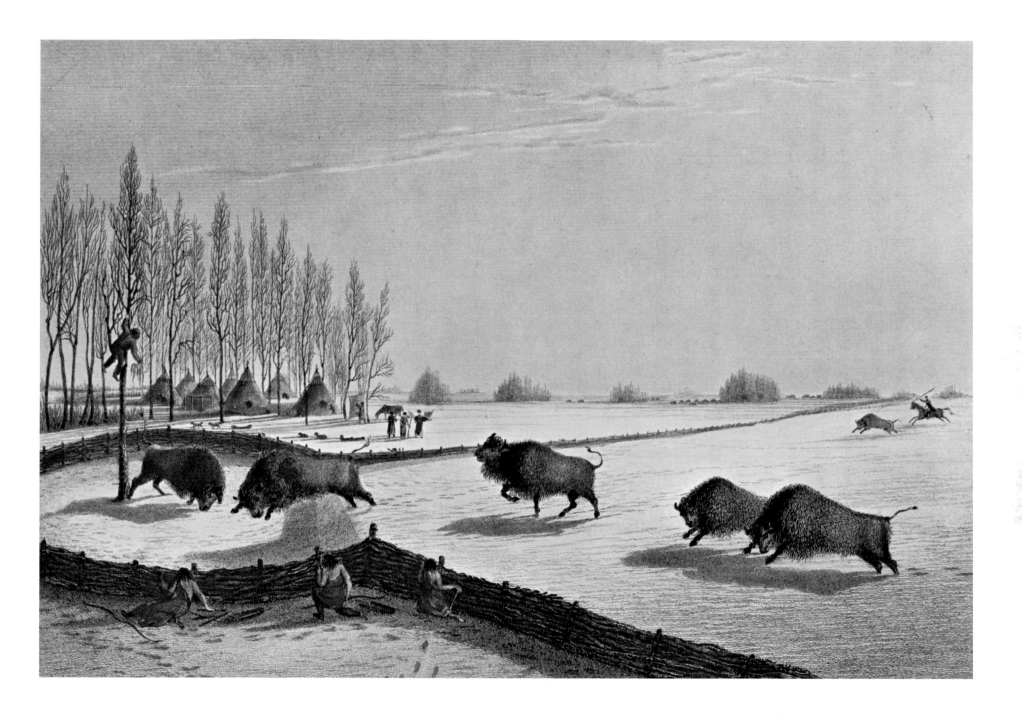

HERD OF BUFFALO. William J. Hays, 1862. Oil on canvas. 25½ x 48½ inches. Courtesy Denver Art Museum. *An animal painter such as Hays was expected to exhibit equal skills as artist and naturalist, therefore his portraits of the bison were based on field sketches and observations made during his 1860 trip west as well as on anatomical study of skeletons and* *familiarity with scholarly and scientific works. Critics thus deplored Hays's dreamlike depiction of* The Buffalo Herd *in the diffused light of a misty morning rather than in brilliant light to illuminate each detail, and argued that the peculiar frontal angle which emphasized the high hump of the bison to the right of the central figure was an anatomical distortion.*

BUFFALO APPROACHING WATER HOLE. Charles Wimar, 1860. Pastel. 18 x 24 inches. Courtesy Lyle S. and Aileen E. Woodcock. *Wimar immigrated from Germany at age fifteen, then returned to study in Düsseldorf for four years. Thereafter he set up his studio in St. Louis, where he painted dramatic canvases of Indians, buffalo, and the grand terrain of the West. He made three known trips up to the headwaters of the Missouri, gathering sketches and inspiration for his work.*

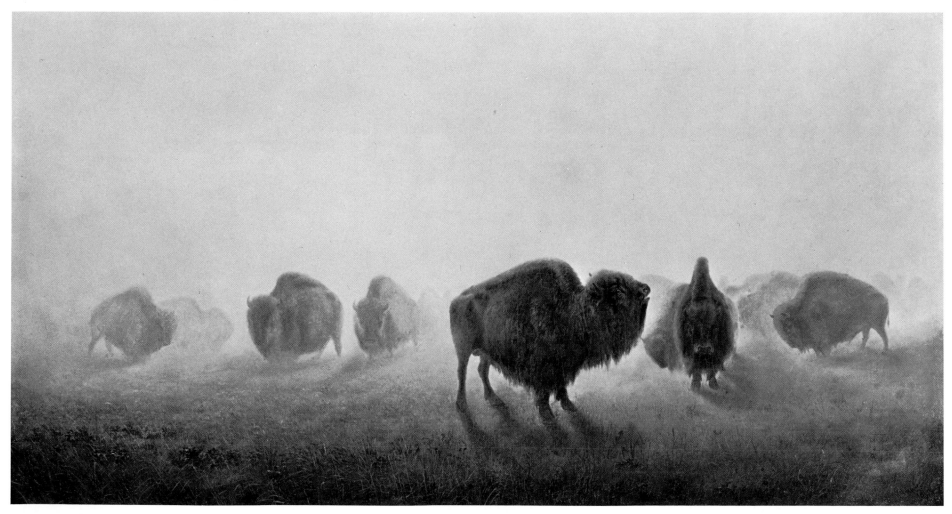

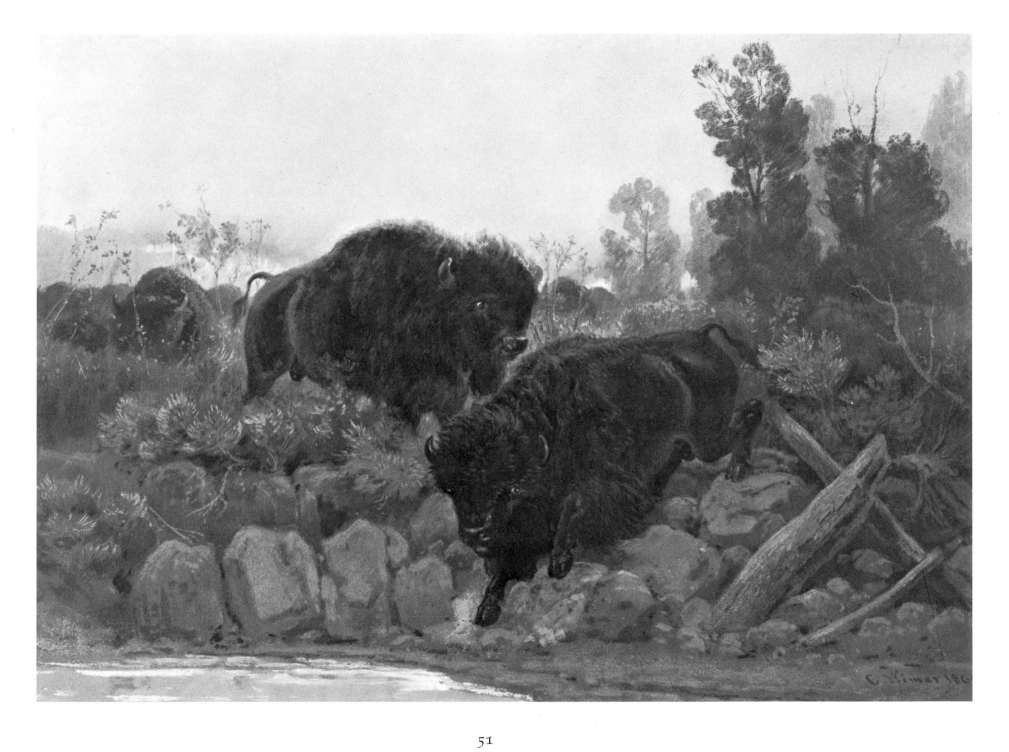

51

[Buffalo grazing alongside a covered wagon train.] Henry Worrall, 1871. Watercolor. 11¾ x 19¼ inches. Courtesy Kansas State Historical Society, Topeka. *Buffalo wallows, like the one Worrall pictured in the lower left portion of this picture, were frequent landmarks throughout the Plains.*

They caught rainwater during the rainy season and forced the wagon trains to wind their way through them. The settlers found the soft soil easy to work into a hasty breastwork in the midst of an Indian battle, but had to plow around them after they had won their land from the red man.

AMERICAN BUFFALOE. Titian Ramsay Peale, 1832. Lithograph (hand-colored). Composition: 6⅜ x 8¼ inches. Courtesy Amon Carter Museum, Fort Worth. *Titian Peale, perhaps the first American artist to observe and paint firsthand the Indians and the buffalo of the Great Plains, accompanied Major Stephen Long's western expedition, 1819 to 1820. This stylized lithograph, published in* Cabinet of Natural History and American Rural Sports, *was based on one of his field sketches.*

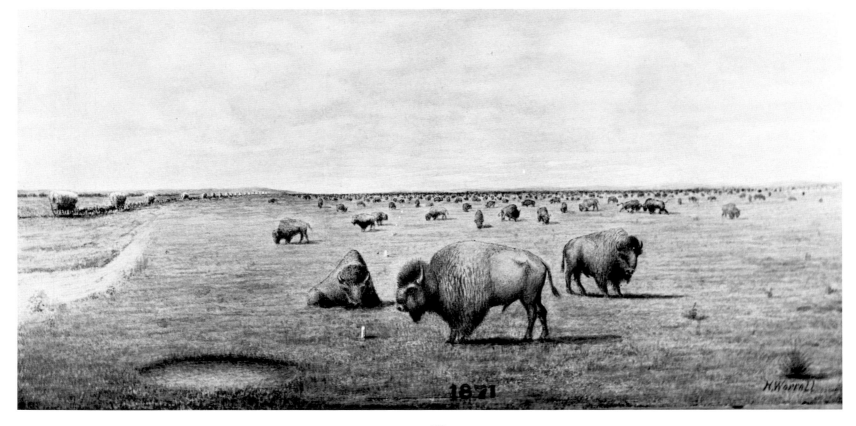

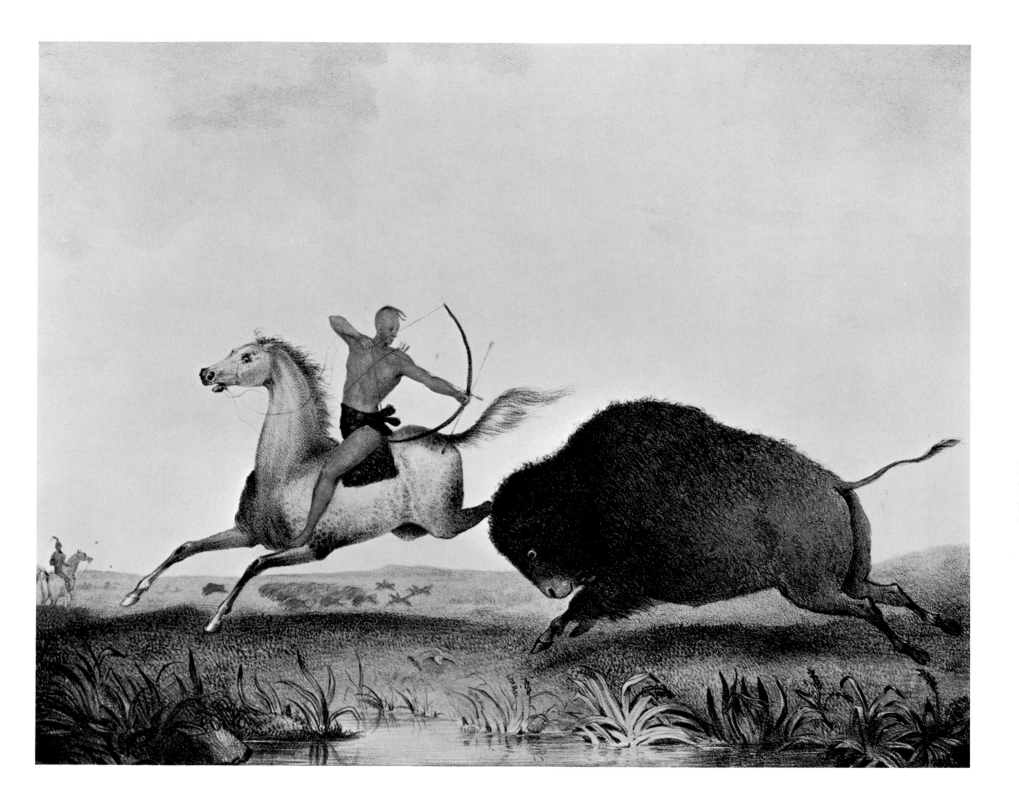

LA CHASSE AU BISON. Unknown, n.d. Lithograph (hand-colored). 10¼ x 13 inches. Courtesy Glenbow-Alberta Institute, Calgary. *Done by an anonymous artist who might never have seen a buffalo hunt, this horse looks more like an Arabian charger than an Indian pony, and the buffalo is amazingly spright — probably smaller than it would have been in relation to the horse.*

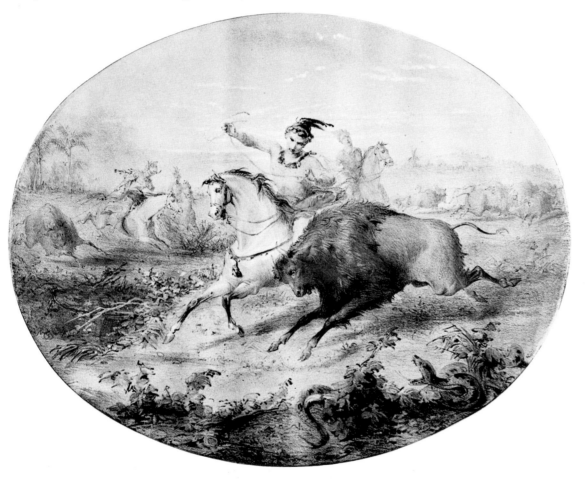

KEEOMA. Charles M. Russell, 1896. Oil on panel. 18½ x 24½ inches. Courtesy Amon Carter Museum, Fort Worth. *Originally used for a magazine story illustration, this painting shows the variety of articles provided by the buffalo for the Plains Indians' comfort and pleasure. A story robe behind Keeoma provides a decorative hanging as well as protection from drafts. A bull-hide shield with a buffalo design can be seen in the upper left, and a parfleche of stiff buffalo rawhide under the willow-slat backrest, probably containing buffalo jerky or pemmican. The beaded pipe bag (see page 34) would be made of buffalo hide, as would the lady's saddle on the opposite side of the composition. The spoon resting in the wooden bowl was probably made of a buffalo horn (see page 34), and another buffalo robe, painted in geometric designs, is showing beneath the bearskin rug. Russell has departed from authenticity in this picture, probably to show the design on the painted items. The buffalo shield, for example, would be covered, for it was considered a sacred object (see page 28), and the painted hide would not be used as a tipi liner. The objects depicted in the picture are portraits of items in the sizeable collection of artifacts assembled by Russell, and Nancy, his wife, probably modeled for the portrait of Keeoma.*

HERD OF BUFFALO CROSSING THE UPPER AS-
SINIBOINE RIVER. Frederick A. Verner,
1875. Watercolor on paper. 12⅛ x 25½
inches. Courtesy Amon Carter Museum,
Fort Worth. *One of Ontario's most re-
nowned artists, Verner was trained in En-
gland and pursued a career there and in
Canada. He made numerous trips to his* *homeland in the Northwestern prairie in
an effort to record the wilderness and wild-
life that was so quickly being destroyed by
civilization's greedy exploiters. The result-
ing oils and watercolors were always pop-
ular entries at the Ontario Society of Art-
ists Exhibitions throughout the 1870s.*

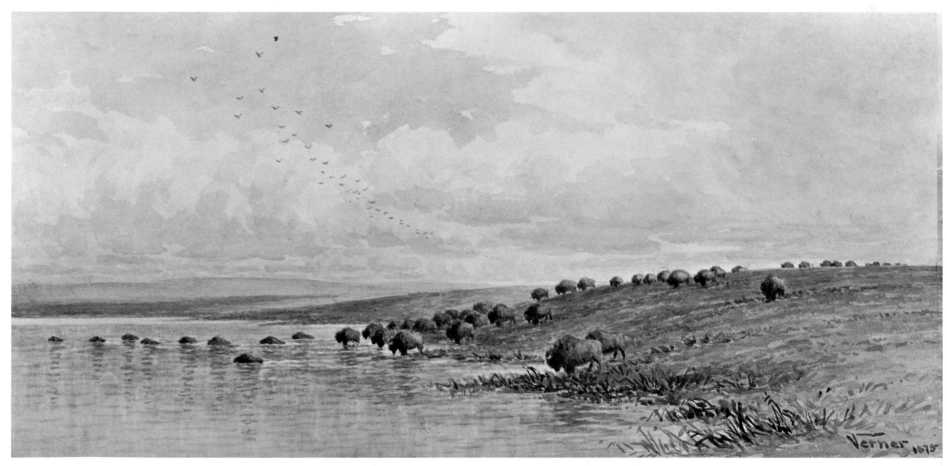

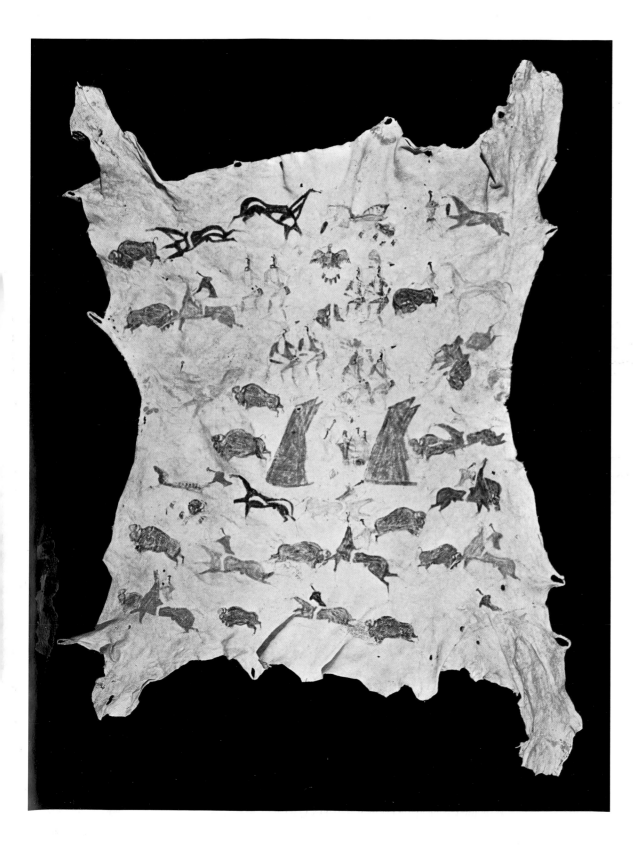

SHOSHONE ROBE. Unknown, circa 1900. Painted elk hide. 65 x 75 inches. Courtesy Buffalo Bill Historical Center, Cody, Wyoming. Loaned by Mrs. Albert E. Bradbury, Mr. William N. Brimmer, and Mr. John G. Brimmer. *The painted robe originally served as a biography of its wearer, pictographically proclaiming his accomplishments in hunting and battle. Gradually these proud statements of prowess were replaced by trade blankets. Later robes were painted for money or barter goods.*

BUFFALO HUNTING. George Catlin, 1863. Oil on canvas. 16 x 21¼ inches. Courtesy Northern Natural Gas Company Collection, Joslyn Art Museum, Omaha. *Catlin spent only six years on the Plains, but he painted the buffalo all his life. This scene, and a related depiction of the winter hunt in snow, are powerful in their emphasis on the dying bull rather than the action of the chase.*

WESTERN INSURANCE CO. OF BUFFALO. n.d. Color lithograph. 21⅞ x 27⅞ inches. Courtesy Amon Carter Museum, Fort Worth. *The bison has long been a popular theme in Buffalo, New York, as shown in this insurance company advertisement.*

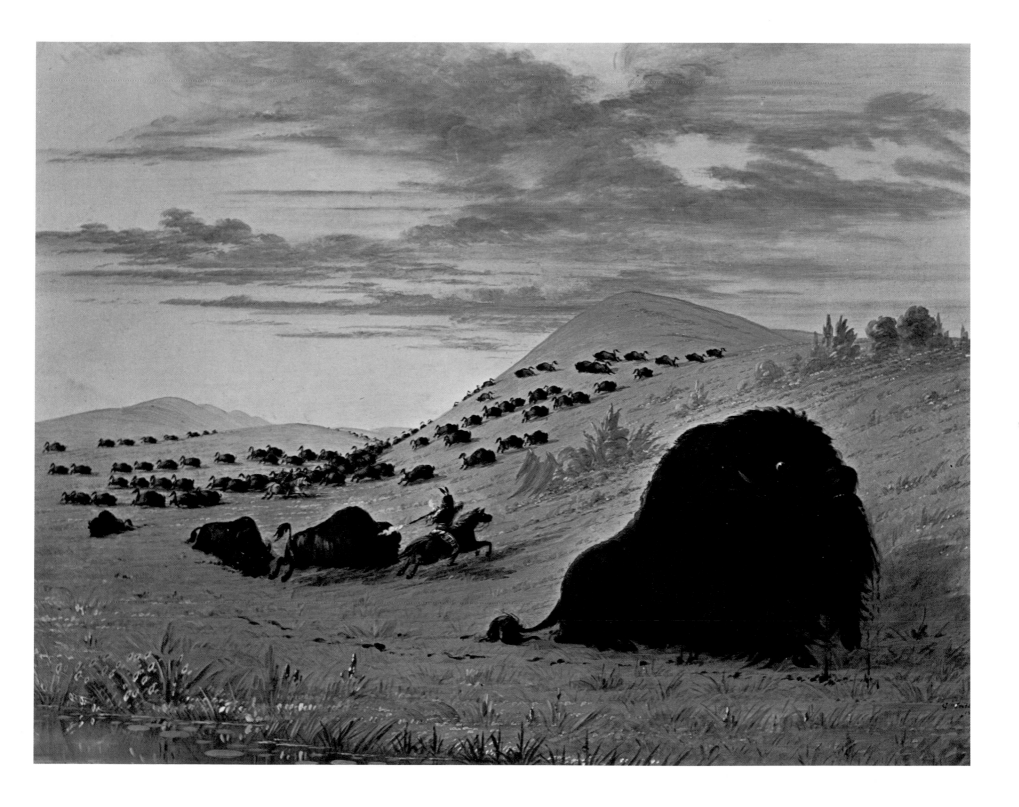

THE STAMPEDE. Frederick A. Verner, 1883. Oil on canvas. 30 x 50 inches. Courtesy Glenbow-Alberta Institute, Calgary. *This painting, one of Verner's many studies of a popular image, shows the bison charging across the vast Canadian prairie. Verner's* repetition of their outstretched running profiles clearly illustrates the peculiar cock of their tails, a characteristic that arrested the attention of so many observers and often differentiates the bison form from that of other animals in Indian designs.

THE HERD ON THE MOVE. William J. Hays, 1862. Color lithograph. 22 x 38¾ inches. Courtesy Amon Carter Museum, Fort Worth. *The first painting that Hays did after his trip west in 1860 is pictured here in lithographic form. Critics were incredulous over the infinite numbers of bison pouring into the foreground, but witnesses soon verified the authenticity of Hays's picture.*

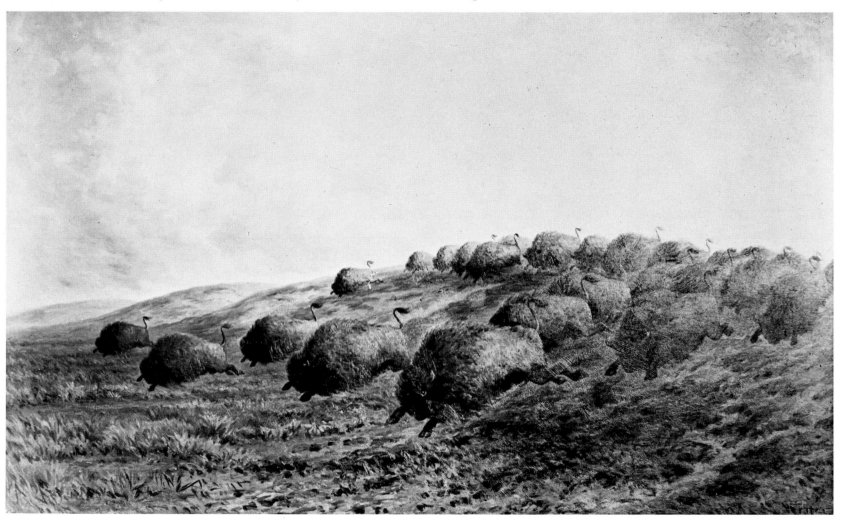

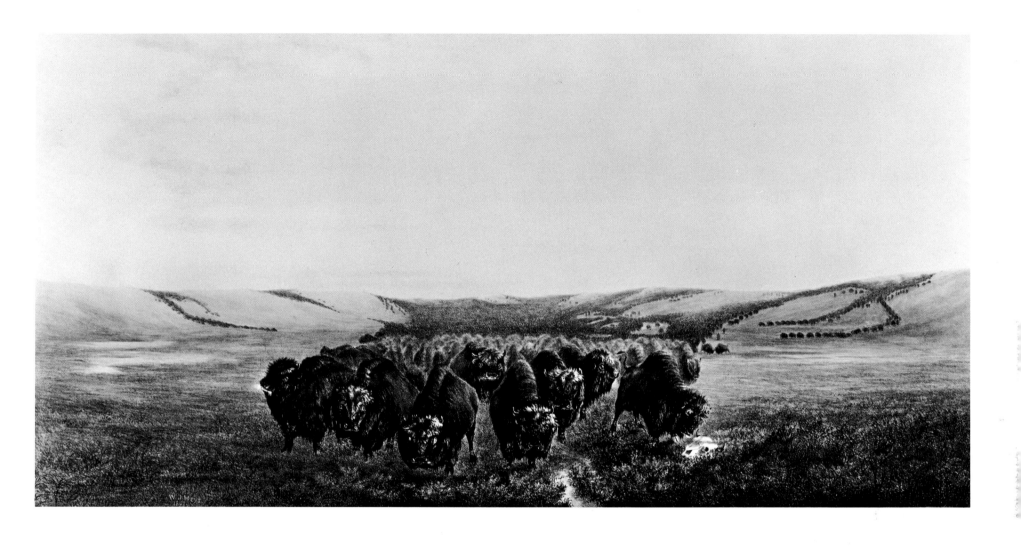

61

INCIDENT ON THE PRAIRIES. J. W. Casilear, 1844. Engraving in George Wilkins Kendall, *Narrative of the Texan Santa Fé Expedition* . . . (New York, 1844), vol. 1. 3½ x 5⅞ inches. Courtesy Amon Carter Museum, Fort Worth. *"One of the wagon-curtains had at first prevented us from seeing . . . the buffalo,"* wrote Kendall, *"but as she swiftly sped past us . . . an Indian, who could not be more than ten yards behind her, appeared in full view." Thus Kendall and his colleagues, en route to what they hoped would be the conquest of New Mexico, witnessed the beginning of a typical buffalo hunt. The Indian had inadvertently driven the beast into their party, whereupon one of Kendall's colleagues shot it. The buffalo proved to be "young, and exceedingly fat and delicious," concluded Kendall.*

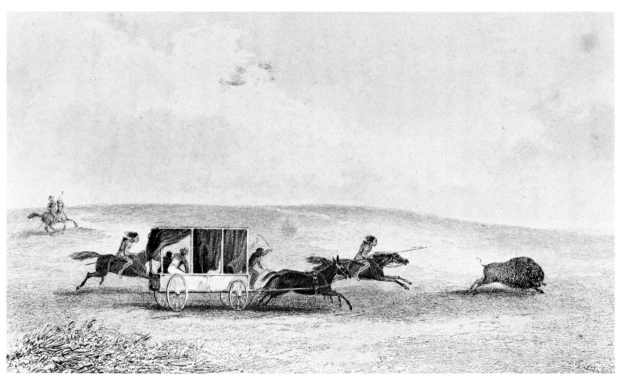

WOLVES ATTACKING BUFFALO. William De La Montagne Cary, n.d. Oil on canvas. 18½ x 27⅜ inches. Courtesy Glenbow-Alberta Institute, Calgary. *In 1861 Cary left New York City with two friends to begin his great Western adventure. In North Dakota their steamboat's boiler exploded, forcing them to raft back to civilization. Undaunted, they joined a wagon train which was subsequently captured by Crow Indians. Finally, they joined an army surveying party and proceeded to Walla Walla, where they boarded a boat for California, then sailed home by way of the Isthmus. These exploits, and those of another trip in 1874, provided Cary with a trove of material that added authenticity to paintings like this tragic but common incident of wolves attacking a buffalo.*

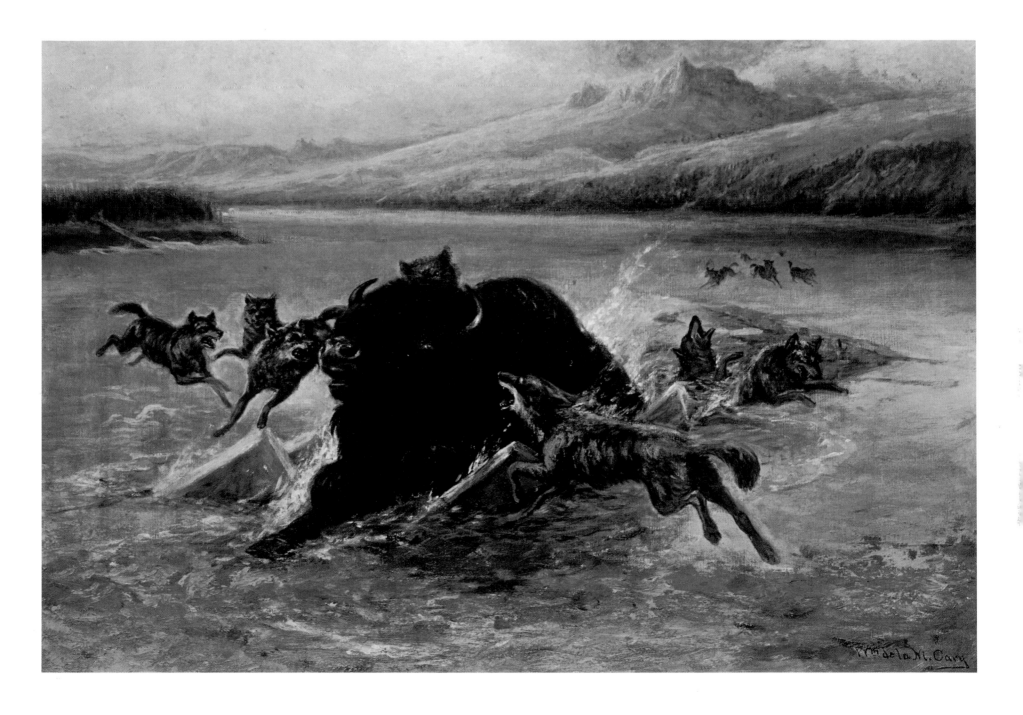

MEDICINE SIGN OF THE ASSINIBOIN INDIANS TO ATTRACT BISON, NEAR FORT UNION, JULY 1833. Karl Bodmer, 1833. Watercolor on paper. 9⅜ x 12⅛ inches. Courtesy Northern Natural Gas Company Collection, Joslyn Art Museum, Omaha. *Bodmer's excellent training as both a watercolorist and a topographical artist is seen in this rendering of the Assiniboin landmark intended to attract buffalo to their lands.*

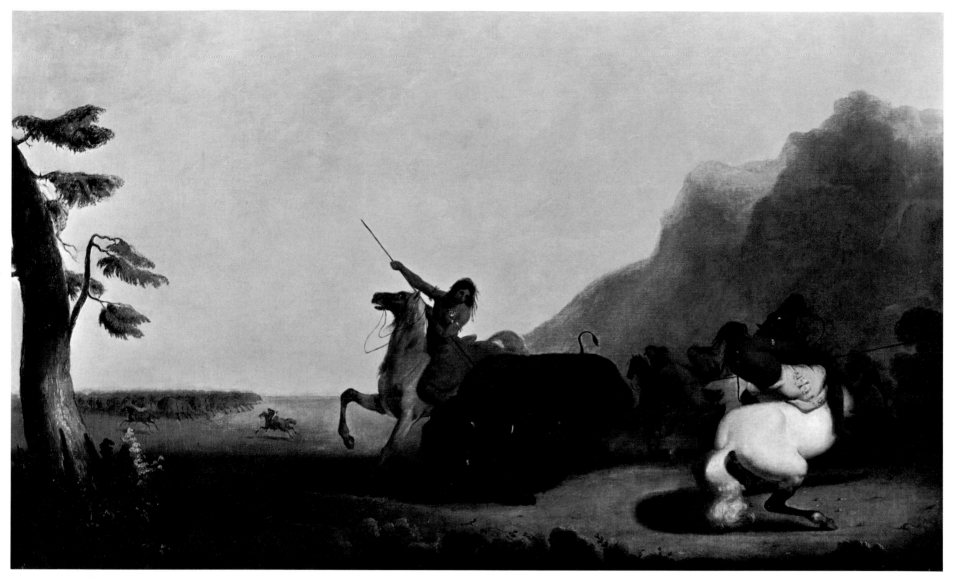

BUFFALO HUNT. Alfred Jacob Miller, n.d. Oil on canvas. 30¼ x 50⅛ inches. Courtesy Amon Carter Museum, Fort Worth. *Upon his return, Miller developed many of his sketches into larger oil paintings, both in Scotland during an 1840–1842 visit to* *Stewart's estate and in his Baltimore studio. Here the artist's early training at the École des Beaux-Arts in Paris shows in the academic style of the pictures, and he lost much of the freshness of the watercolors.*

65

BUFFALO STAMPEDE. Christian Eisele, circa 1890. Oil on canvas. 30 x 50 inches. Courtesy Berry-Hill Galleries, New York City. *An immigrant from Germany, Eisele moved to Utah in 1900 and painted in Colorado, Oregon, and Utah until his death in 1919.*

A WESTERN JURY. John Howland, 1883. Oil on canvas. 36 x 48 inches. Courtesy Northern Natural Gas Company Collection, Joslyn Art Museum, Omaha. *A veteran of the American Fur Company and the Colorado* *Volunteers, Howland was interested in the buffalo and sketched them throughout his western adventures. He later studied art in Paris before settling in Denver.*

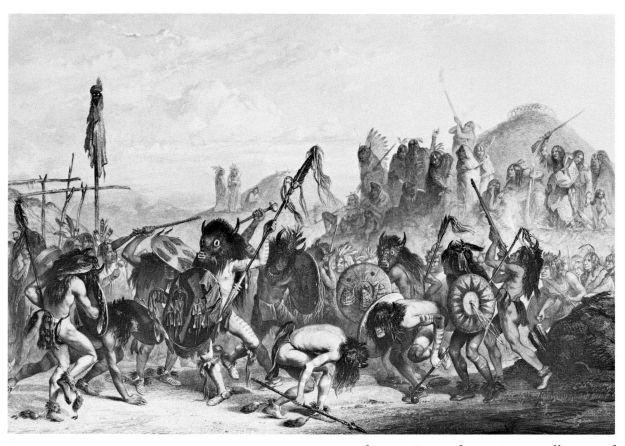

BISON-DANCE OF THE MANDAN INDIANS IN FRONT OF THE MEDICINE LODGE IN MIH-TUTTA-HANKUSH. Karl Bodmer, 1840. Aquatint and etching. 17⅜ x 24 inches. Courtesy Amon Carter Museum, Fort Worth. *Bodmer probably used sketches like that of the single bison-dancer as visual notes in executing this larger scene. Unlike other tribes that followed the buffalo, the Mandans maintained permanent villages and developed highly sophisticated ceremonies to lure the herds within hunting range. One such ceremony was the bison dance, a spirited mime of the hunt in which the hunters represented the buffalo and the rest of the tribe acted as hunters. It lasted for days, exhausted the dancers, and ended only with the sighting of a herd.*

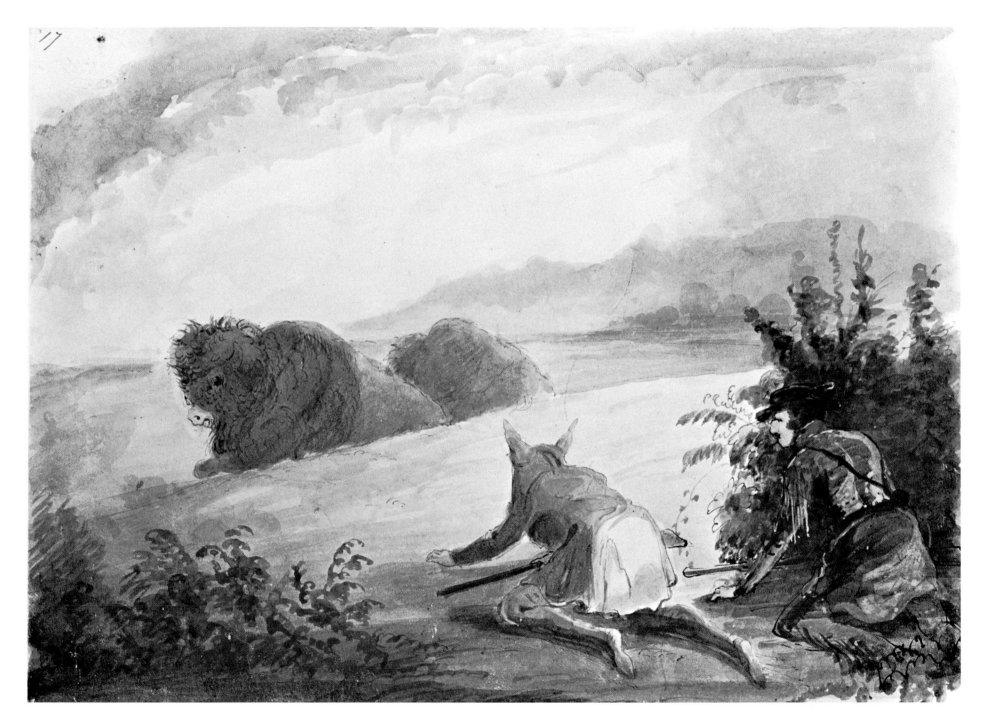

TAKING THE HUMP RIB. Alfred Jacob Miller, circa 1837. Pen and ink wash on paper. 8⅛ x 10⅞ inches. Courtesy Amon Carter Museum, Fort Worth. *Miller termed the "hump rib" — meat extracted from the hump of the buffalo — "probably superior* *to all meats whatsoever." This, along with the true ribs and tongue, were taken back to camp, and the carcass left on the prairie for scavengers. Such selectivity testifies to the abundance of the herds before settlement of the Great Plains.*

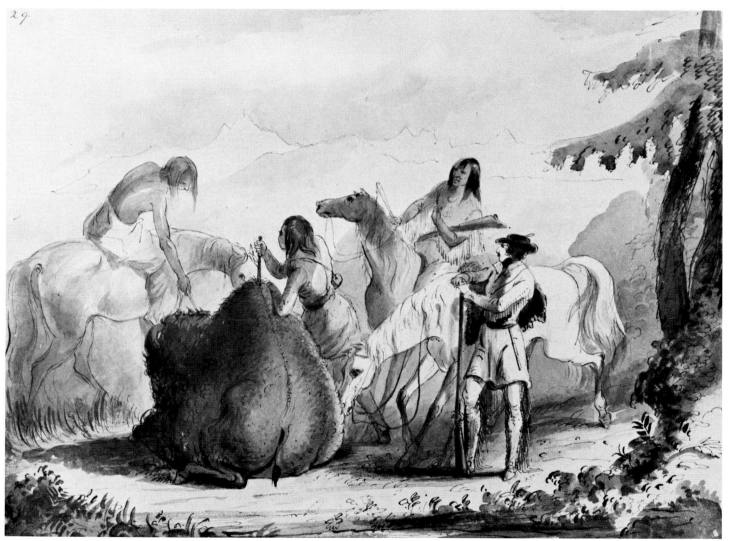

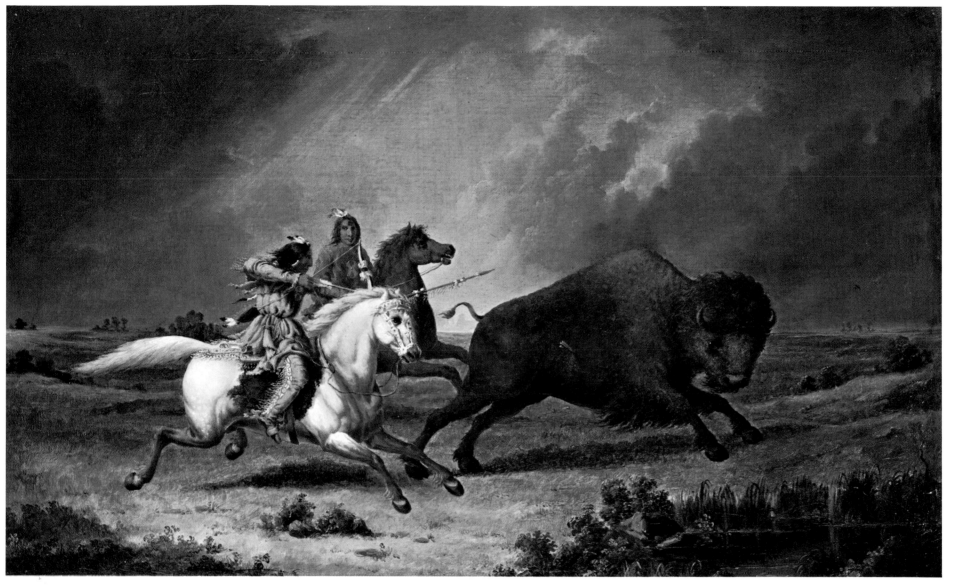

ASSINIBOIN HUNTING BUFFALO. Paul Kane, n.d. Oil on canvas. 18½ x 29¾ inches. Courtesy The National Gallery of Canada, Ottawa. *Paul Kane immigrated as a boy from Ireland to Toronto. Childhood memories of Indians and admiration for the* *work of Catlin and Stanley inspired him to paint the natives and landscape of the Canadian West. In 1845 he set out from Toronto on a three-year journey to the Pacific coast, producing some 500 sketches, the basis of most of his future work.*

71

HERD OF BUFFALO FORDING A RIVER. Rudolph Friedrich Kurz, n.d. Black chalk on buff paper. 12 x 18⅝ inches. Courtesy Museum of Fine Arts, Boston, M. and M. Karolik Collection. Fort Worth only. *Kurz left Switzerland in 1846, fulfilling a boyhood dream of traveling to the American West and recording the ways of its native* peoples and animals. *To prepare he had specifically trained himself in perfecting his powers of observation and rapid life-study sketching techniques. He spent six years in the Upper Missouri region, making his sketchbook a rare eye-witness record of the then unspoiled but rapidly changing West.*

THE BUFFALO HUNT. Frederic Remington, 1890. Oil on canvas. 34 x 49 inches. Courtesy Buffalo Bill Historical Center, Cody, Wyoming. *In 1890 Remington made three trips West. "I knew the wild riders and the vacant land were about to vanish forever, and the more I considered the subject the bigger the Forever loomed," he wrote. He determined to do his best to save the West on canvas. His Buffalo Hunt was painted that year.*

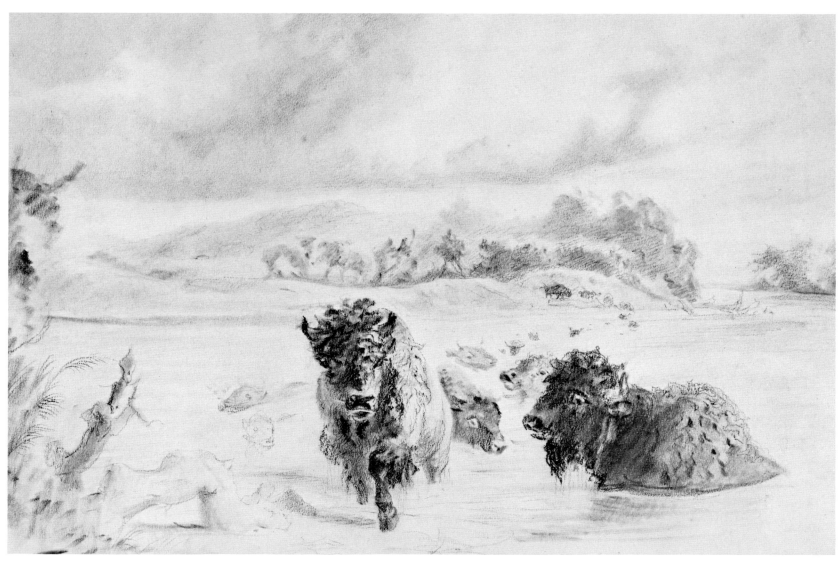

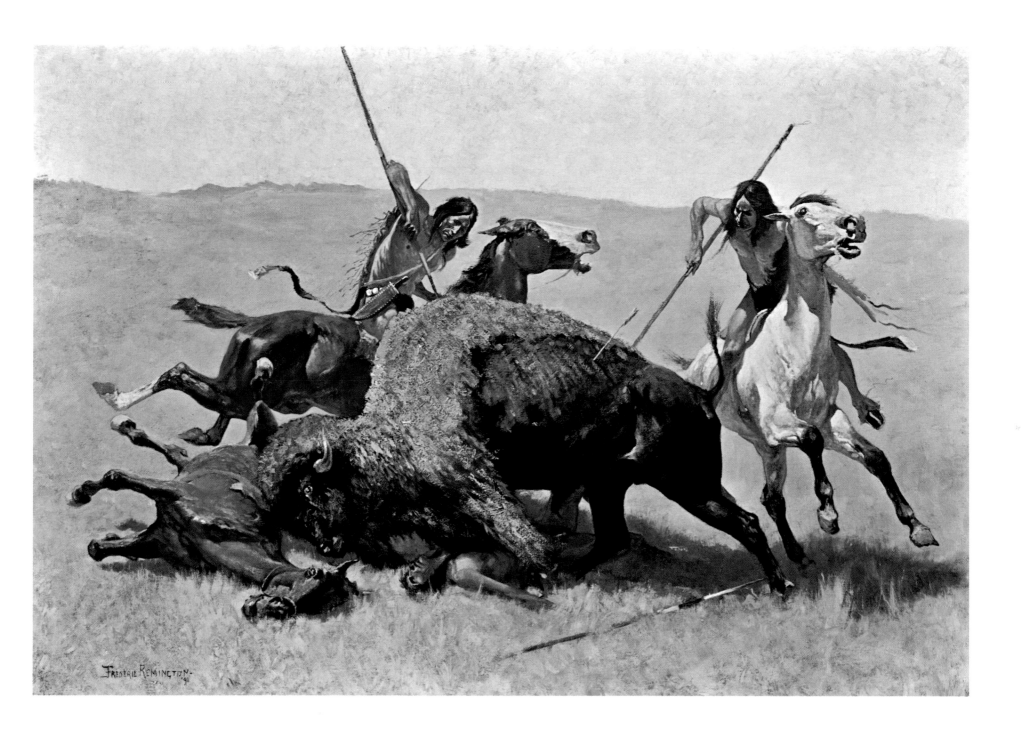

MEAT FOR WILD MEN. Charles M. Russell, modeled circa 1920. Cast 1924 by the Nelli Art Bronze Foundry, Los Angeles. Bronze. 11½ inches high. Courtesy Amon Carter Museum, Fort Worth. *Russell first exercised his sculptural skills by modeling animals from lumps of wax as campfire entertainment during his cattle-driving days.*

His first full-figure bronze was cast in 1903. The buffalo and the Indian were two of his favorite subjects. In this dramatic and complex sculpture, Russell shows one method by which the Indians hunted the buffalo, isolating a group and riding in circles around it until all inside were killed.

BUFFALO HUNTER. Unknown, circa 1830. Oil on canvas. 40 x 52 inches. Courtesy Santa Barbara Museum of Art. Gift of Harriet Cowles Hammett in memory of Buell Hammett. *The anonymous artist who did this superb picture probably copied it from an early lithograph of the buffalo hunt. It is done in the tradition of folk artists of the 1830s, but is unusual in size and quality. It is similar to an engraving by Felix O. C. Darley entitled* Hunting Buffaloe, *which appeared in* Graham's Magazine *in 1844.*

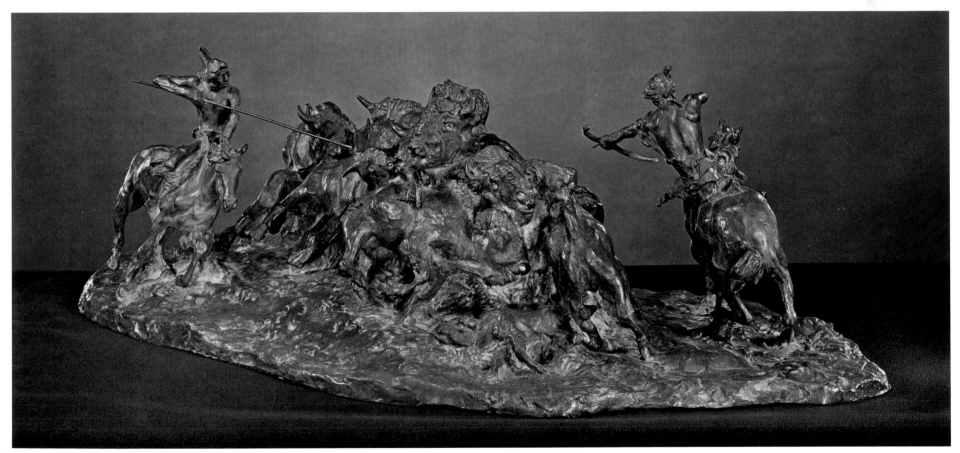

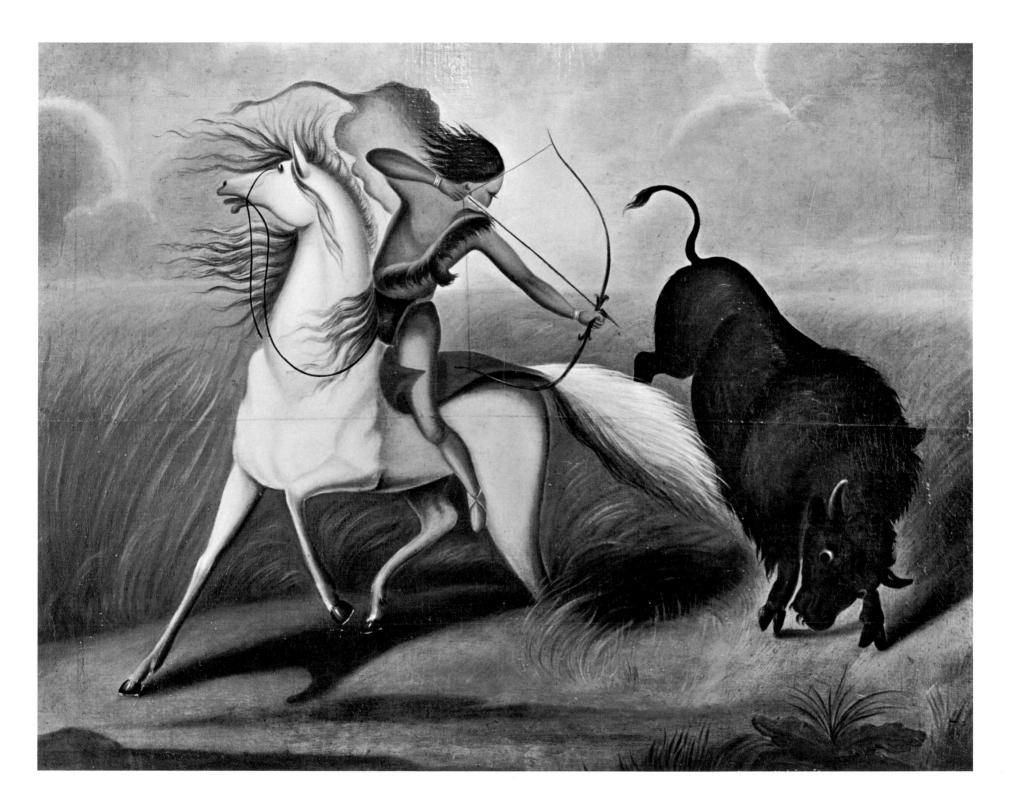

CHEYENNES AFTER BUFFALO. Buffalo Meat, 1876. Pen and ink, pencil, colored pencil on paper. 8¾ x 11¼ inches. Courtesy Amon Carter Museum, Fort Worth. *This painting by Buffalo Meat, an insurgent Cheyenne chief imprisoned at Fort Marion, Florida, clearly shows the intrusion of white men's ways into Native American hunting techniques. Buffalo Meat depicts himself (in top hat) killing two buffalo with the traditional bow and arrow, but his companion attacks another animal with both arrows and a pistol.*

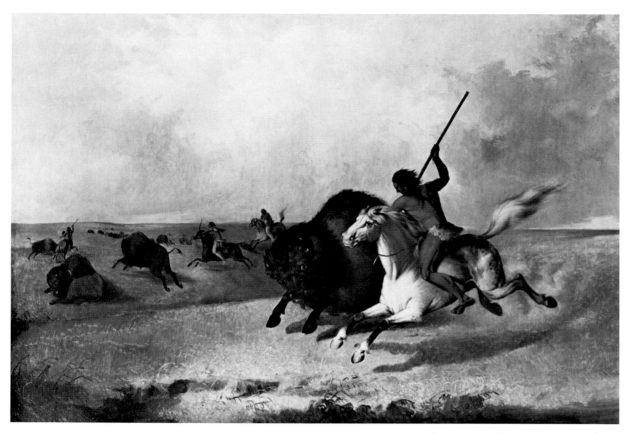

A BUFFALO HUNT ON THE SOUTHWESTERN PRAIRIES. John Mix Stanley, 1845. Oil on canvas. 40¼ x 60¾ inches. Lent by the National Collection of Fine Arts; courtesy the Department of Anthropology, Smithsonian Institution. *Stanley was a largely self-taught painter who, like Catlin, was interested in documenting the West and depositing his collection in the Smithsonian Institution where it would be preserved and studied. He began his career painting Indians in Indian Territory, then traveled to California with Lieutenant William H. Emory and along the northern railway route with Isaac Stevens. Reproductions of his work are published in both Emory's and Stevens's reports. He had the opportunity to see countless buffalo hunts and correctly portrays it here: the lancer approached from the animal's left, if possible.*

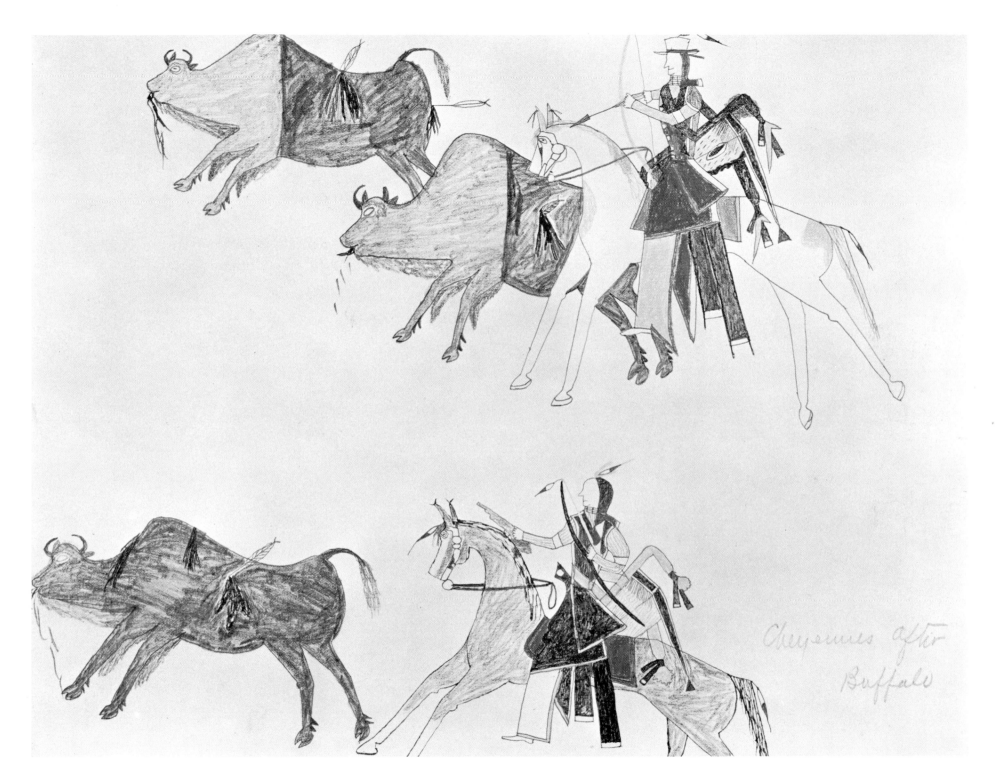

Cheyennes after
Buffalo

THE BUFFALOES IN FRANKLIN'S JOURNAL. After George Back, 1823. Sepia wash on embossed card. 3⅛ x 4½ inches. Courtesy Amon Carter Museum, Fort Worth. *Based on Back's description of a buffalo pound,* *this fanciful drawing of frolicking buffalo was executed by an unknown artist who, like many Europeans, avidly read the published adventures of explorers in what was still the New World.*

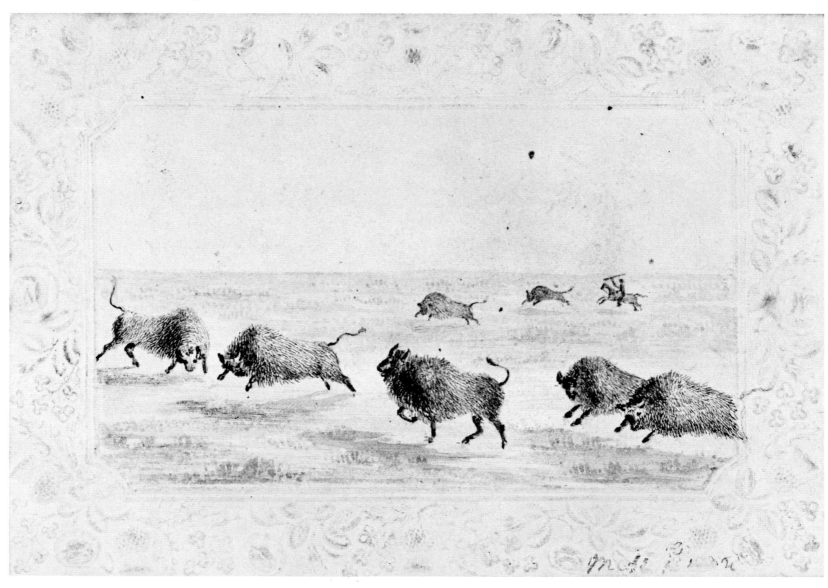

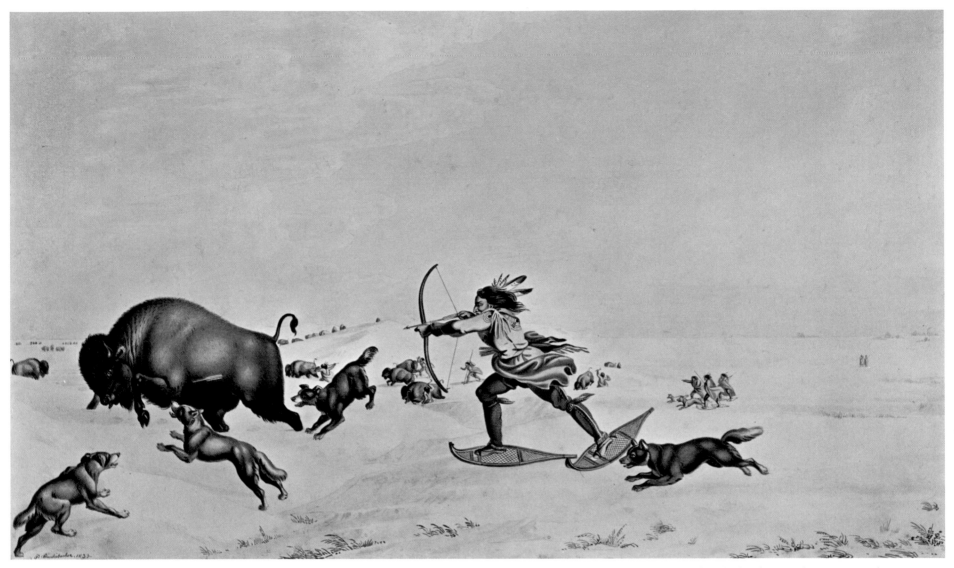

BLACKFEET HUNTING ON SNOWSHOES. Peter Rindisbacher, 1833. Watercolor on paper. 9¾ x 16⅜ inches. Courtesy Amon Carter Museum, Fort Worth. *As a settler rather than a visitor in the Canadian West, Rindisbacher had a singular opportunity to* *observe in detail the life and customs of the local Blackfoot tribes. In winter, their hunting was facilitated by the frozen snow, which would bear the weight of a man on snowshoes while the ponderous buffalo sank into the drifts, unable to escape.*

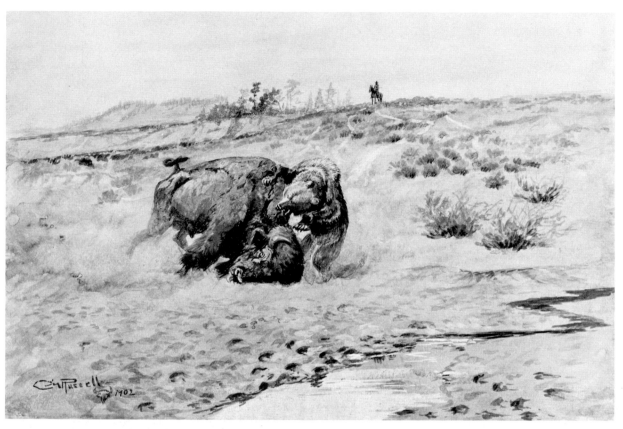

FIGHT ON THE PLAINS. Unknown, circa 1860. Oil on canvas. 20⅛ x 30⅛ inches. Courtesy Amon Carter Museum, Fort Worth. *Wolves attacking a buffalo was a common subject for Western artists (see page 63), so common that this picture could either have been the result of a first-hand observation or the result of seeing another artist's work. It is, however, one of the most dramatic and sympathetic of the "fight" pictures, showing the wolves in what might be their proper proportion to the bison but clearly suggesting that this buffalo will lose its ultimate battle.*

DEATH BATTLE OF A BUFFALO AND GRIZZLY BEAR. Charles M. Russell, 1902. Gouache on paper. 12 x 17⅞ inches. Courtesy Amon Carter Museum, Fort Worth. Gift of F. J. Adams, Fort Worth. *Charles Marion Russell did not come West to observe. He came, a lad of fifteen, to live the rugged life of a cowboy. Encouraged by friends, however, he began developing his innate artistic talents and keen powers of observation and memory for detail, which eventually enabled him to so grippingly record the vanishing scenes of natural grandeur and human adventure common to the West. Death Battle was based on an incident described to Russell by a Montana pioneer.*

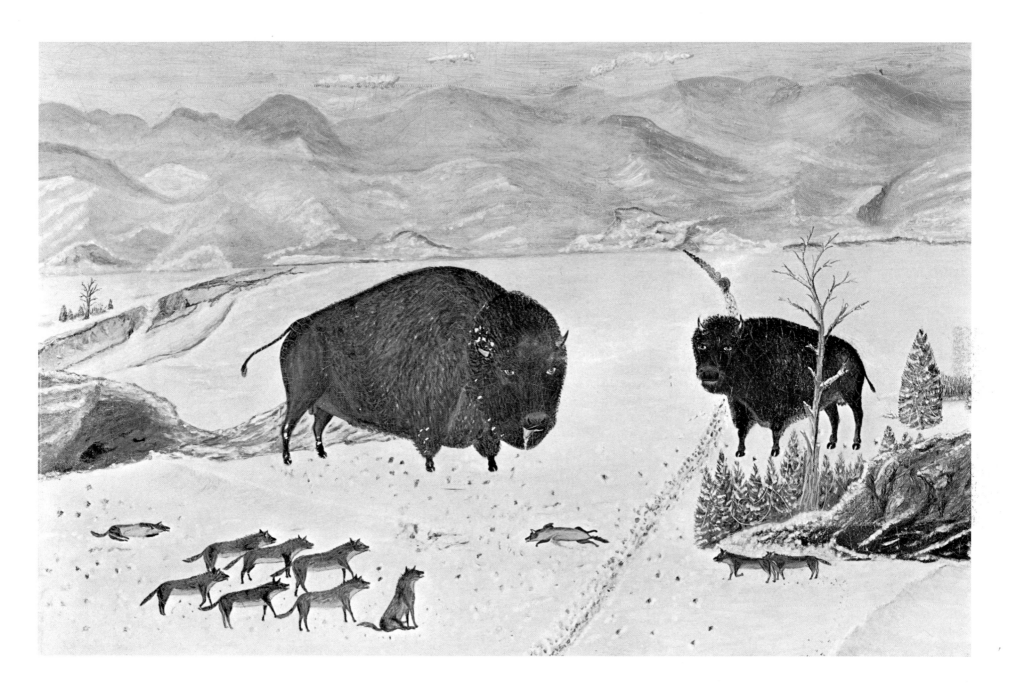

THE BUFFALO HUNT NO. 39. Charles M. Russell, 1919. Oil on canvas. 30¼ x 48¼ inches. Courtesy Amon Carter Museum, Fort Worth. *Russell painted the buffalo hunt several times. This picture, in fact,* *was originally commissioned for exhibition at the Minneapolis Institute of Art, but Will Rogers, Charlie's close friend, persuaded Russell to sell it to him and paint another version for the Institute.*

INDIANS SIMULATING BUFFALO. Frederic Remington, 1908. Oil on canvas. 27⅛ x 40¼ inches. Courtesy Toledo Museum of Art, Toledo, Ohio. Gift of Florence Scott Libbey. Fort Worth only. *Slumping over the withers of their ponies and covering themselves with buffalo robes, Plains Indians could realistically imitate peacefully grazing, hump-backed buffalo. This technique allowed them to approach wary game on the vast coverless prairie.*

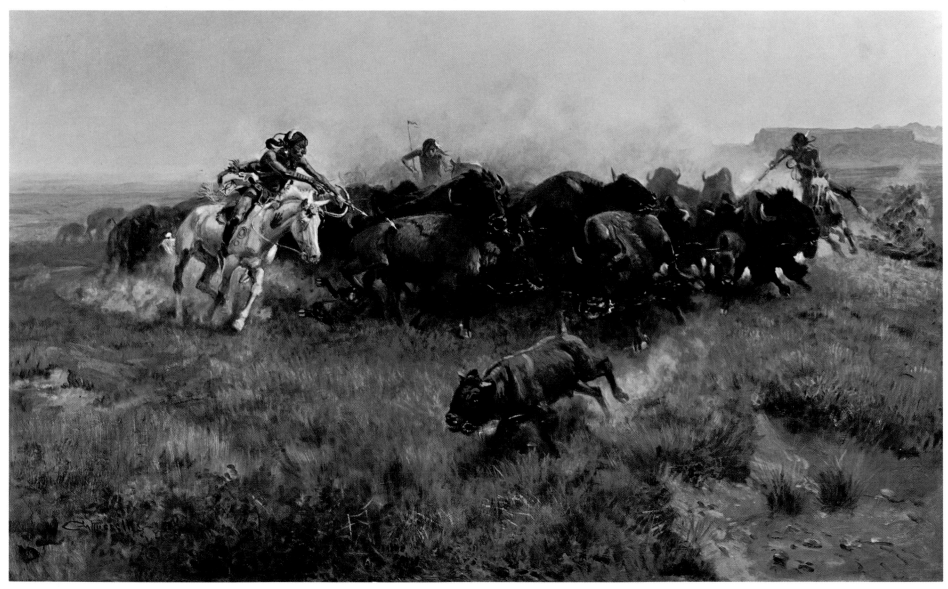

AN INDIAN HORSE DANCE. Kills Two, n.d. Copyright 1938. Silkscreen. 15⅜ x 19⅝ inches. Courtesy Amon Carter Museum, Fort Worth. *In this ceremonial dance of the Sioux horse society, both horse and rider are bedecked with buffalo masks and ornaments and are painted with designs denoting thunder and lightning. Kills Two (1869–1927), an Ogalala Sioux, always began his spirited portrayals of horses by laying in the hooves, then composing the outline. His painting of this dance celebrates the spiritual and physical power of the two animals which shaped the Plains Indian culture, the horse and the buffalo.*

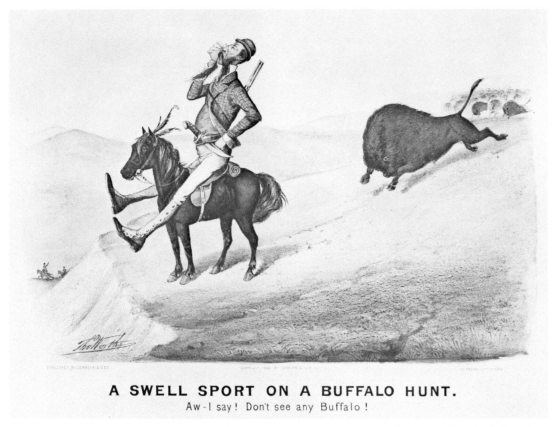

A SWELL SPORT ON A BUFFALO HUNT.

Aw - I say ! Don't see any Buffalo !

A SWELL SPORT ON A BUFFALO HUNT. Thomas Worth, 1882. Lithograph (hand-colored). Published by Currier & Ives. 13½ x 17¾ inches. Courtesy Amon Carter Museum, Fort Worth. *Worth was one of the most prolific artists who contributed pictures for Currier & Ives. Born and raised in New York City, he was unfamiliar with the West, but was an ardent sportsman who had among his specializations a number of comic prints.*

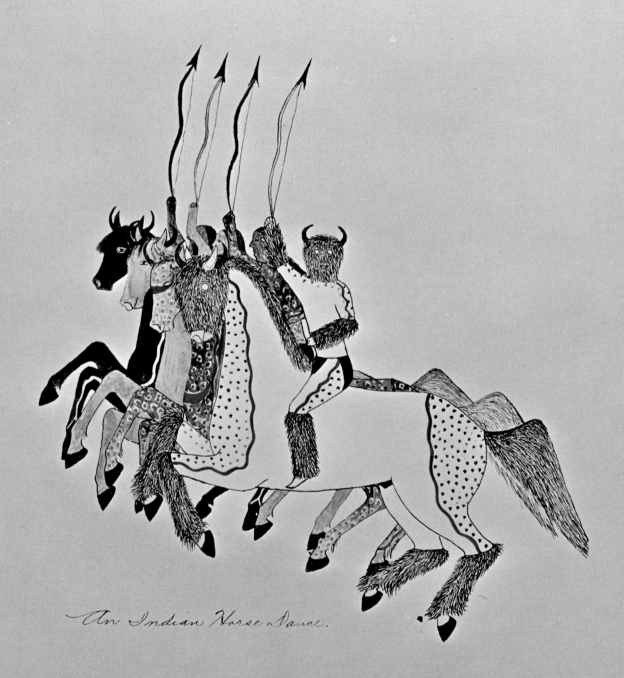

An Indian Horse Dance.

MEDICINE CIRCLES. Alfred Jacob Miller, circa 1858. Watercolor on paper. 9 x 12¼ inches. Courtesy The Walters Art Gallery, Baltimore. *Miller was fascinated by the circles of skulls the Indians patterned on* *the prairies to attract the buffalo, but could not obtain an explanation of their meaning. Perhaps this is why he painted them bathed in moonlight, with overtones of gothic mystery.*

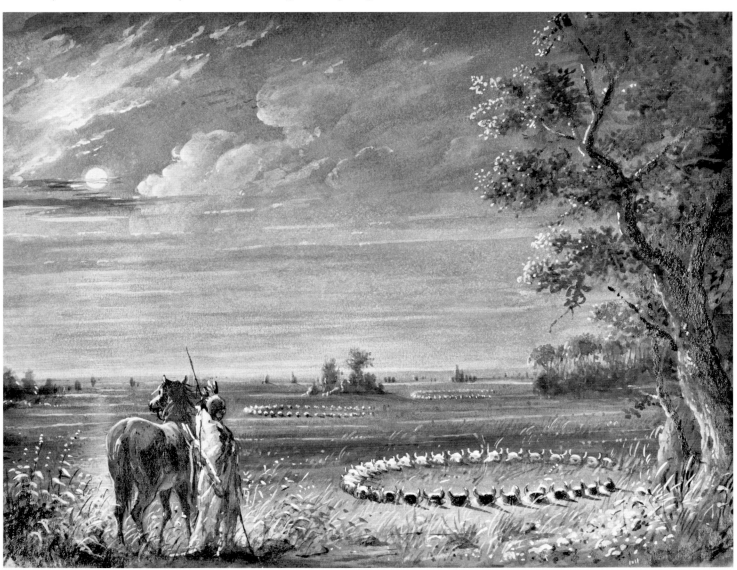

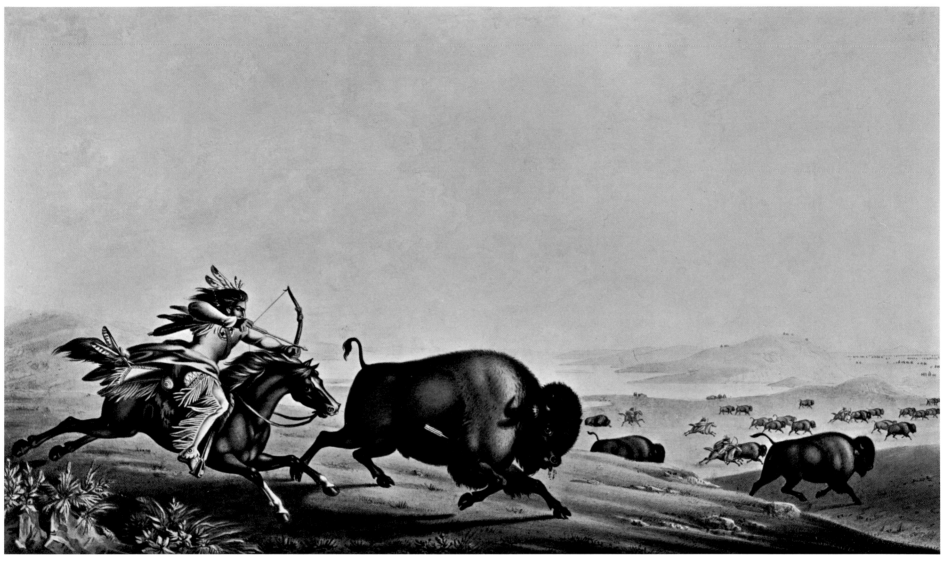

BLACKFEET HUNTING ON HORSEBACK. Peter Rindisbacher, 1833. Watercolor on paper. 9¾ x 16⅛ inches. Courtesy Amon Carter Museum, Fort Worth. *A Swiss emigrant at the short-lived Red River Colony in present-day Manitoba, Peter Rindisbacher supplemented his family's meager income by* *selling his watercolors of local sights to neighboring Hudson's Bay Company officials. His handling of the horseback buffalo hunt by Indians is considered particularly authentic, and by 1824 he was receiving other commissions because of his skill in rendering this vivid scene.*

CARICATURE OF BUFFALO BILL ON BUFFALO. Henry H. Cross, circa 1890. Watercolor on paper. 11 x 14 inches. Courtesy Buffalo Bill Historical Center, Cody, Wyoming. *Cross was an ardent fan of Buffalo Bill from the time he ran away from home to join the circus as a child to his study with Rosa Bonheur in Paris, where he frequented the show and fair grounds. He admired just as much Buffalo Bill's Wild West, which he saw upon his return to America.*

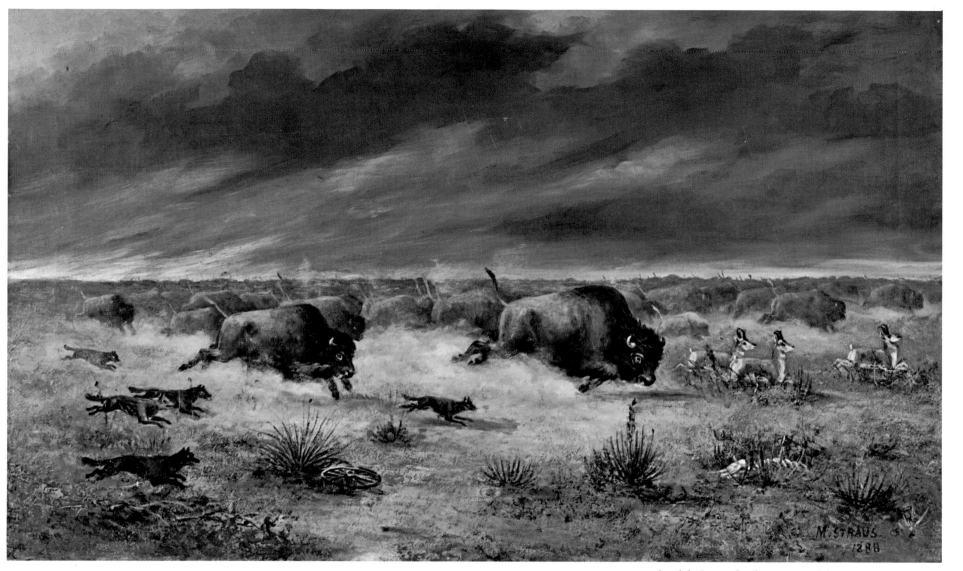

HERD OF BUFFALO FLEEING FROM PRAIRIE
FIRE. Meyer Straus, 1888. Oil on canvas.
17⅞ x 29⅞ inches. Courtesy Amon Carter
Museum, Fort Worth. *Straus immigrated
to America from Bavaria at age seventeen.*

*Poor health brought him to California in
1874, and he settled in San Francisco,
where he earned his living as a painter of
Western scenes. This picture was used as a
U.S. Forest Service poster.*

THE GREAT ROYAL BUFFALO HUNT. Louis Maurer, 1894. Oil on canvas. 34 x 54 inches. Courtesy Buffalo Bill Historical Center, Cody, Wyoming. *Maurer shared several of Tait's visits to the Astor Library* *to do research for his pictures, but he later made two extensive Western trips which greatly improved his knowledge of the region. This picture depicts one of the most famous of all the buffalo hunts: William* *Frederick "Buffalo Bill" Cody escorting the Russian Grand Duke Alexis and Lieutenant Colonel George Custer. The Indian is probably Chief Spotted Tail of the Sioux, who also hosted the Duke and Custer.*

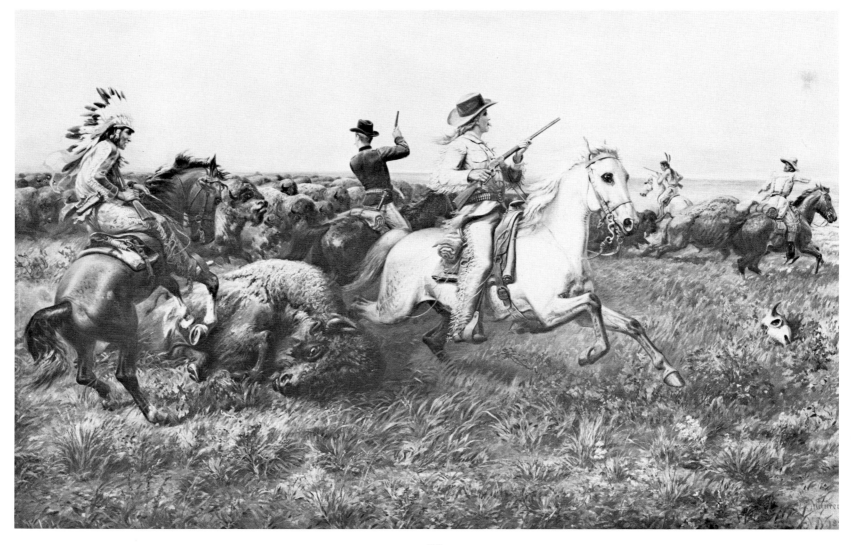

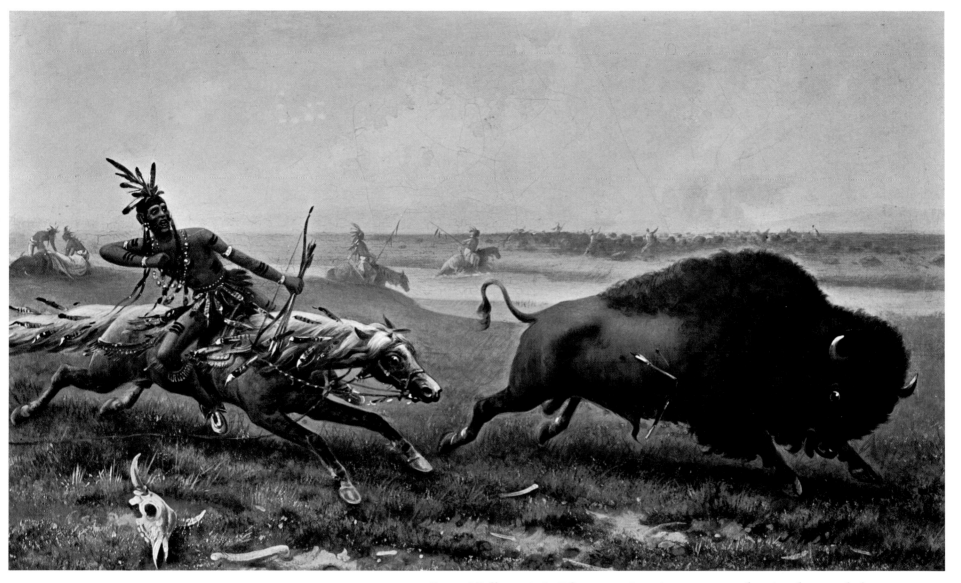

BUFFALO HUNT. James Walker, 1878. Oil on canvas. 12 x 20 inches. Courtesy Harmsen's Western Americana Collection. *While Walker, a British-American artist, was touring Mexico in 1846, war between Mexico and the United States erupted. He stayed to serve as an interpreter with the American army and painted several dramatic scenes of battle. He was so taken with Latin America that he extended his travels to South America and Southern California. He is best known for his battle and vaquero scenes.*

HUNTING BUFFALO. Alfred Jacob Miller, circa 1858. Watercolor on paper. 8¼ x 14⅛ inches. Courtesy The Walters Art Gallery, Baltimore. *Although the Plains Indians did on occasion run buffalo over cliffs to disable them for easy kill, Miller's* depiction sacrifices authenticity for the *sake of drama. Such a fall would have spoiled the meat, to say nothing of the treacherous climb the Indians would have faced bringing back the meat.*

INDIAN BETWEEN TWO CULTURES. Wohaw, 1870s. Pencil and crayon drawing on paper. 8¾ x 11¼ inches. Courtesy the Missouri Historical Society, St. Louis. *A Kiowa warrior and later a prisoner at Fort Marion, Florida, Wohaw depicted himself, and symbolically his people, astride two cultures. He offers both the bison and the beef cow the sacred pipe and basks in their mingled breath while the sun, moon, and shooting star witness his covenant.*

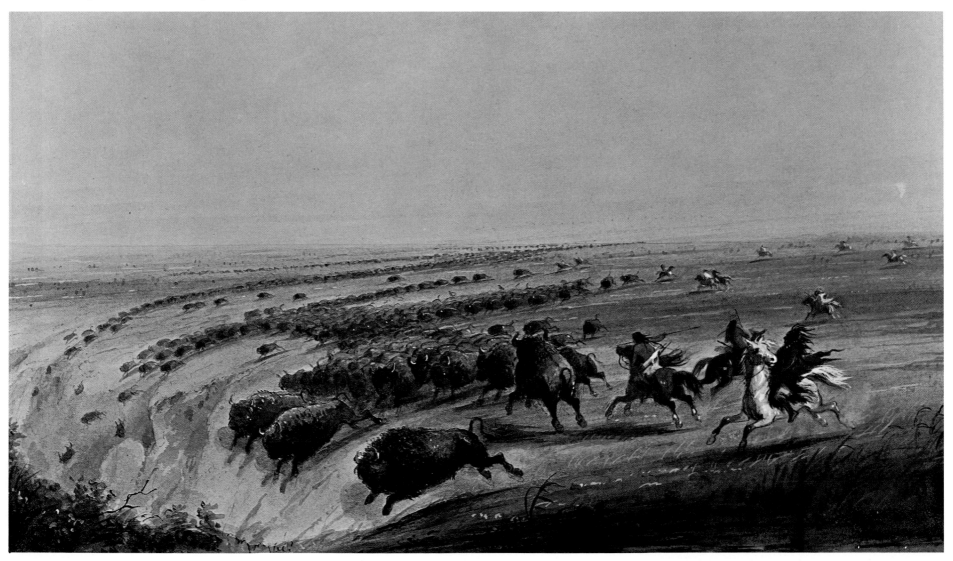

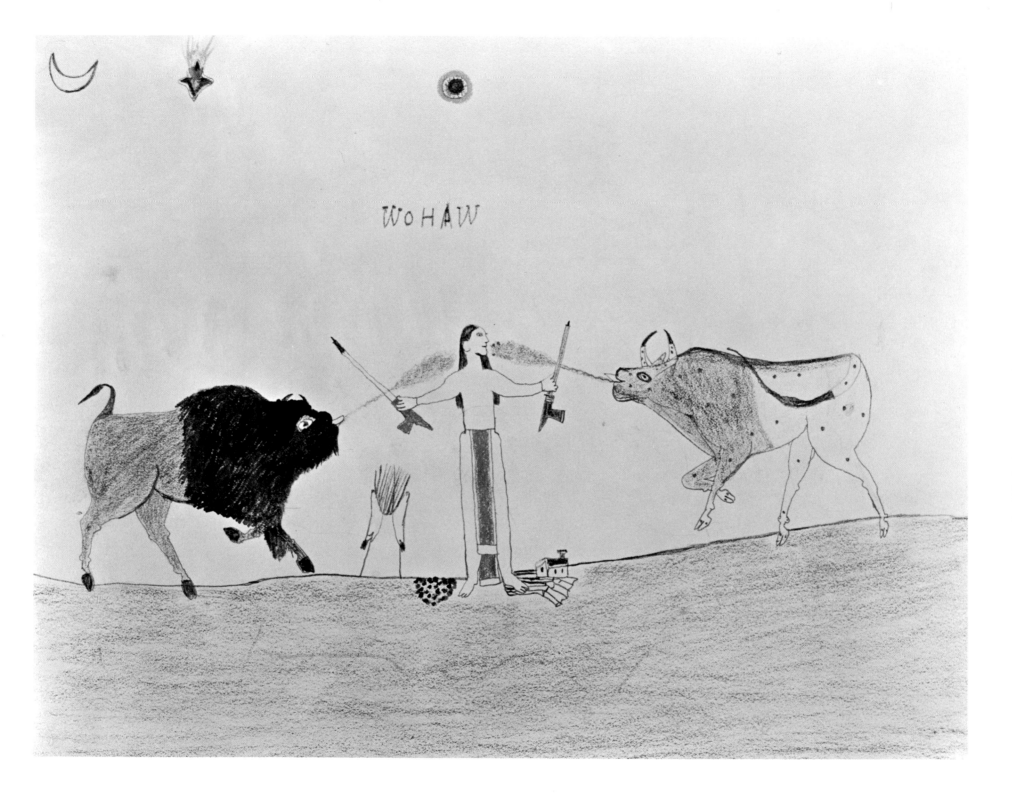

MAP OF TEXAS, COMPILED FROM SURVEYS RE-
CORDED IN THE LAND OFFICE OF TEXAS, AND
OTHER OFFICIAL SURVEYS. John Arrowsmith,
1841. 23¾ x 20 inches. Etching (bounda-
ries colored). Courtesy Mrs. Jenkins Gar-
rett Collection, Fort Worth. *The Arrow-
smith maps are the best and most useful
maps of their time, according to the bibli-
ographer Thomas W. Streeter, who gath-
ered maps of this era for years. An inter-
esting note to prospective immigrants were
the notations near the northern forks of
the Canadian River that there were "Buf-
falo & Elk" and "Buffalo & wild horse" in
the Lone Star State.*

HERD OF BISON, NEAR LAKE JESSIE. John Mix
Stanley, 1855. Color lithograph. 8⅝ x
11¼ inches. Courtesy Amon Carter Mu-
seum, Fort Worth. *Stanley turned in 1842
from painting fashionable portraits in pro-
vincial cities to interpreting the West.
He accompanied governmental expeditions
through the South- and Northwest, mak-
ing a visual record of the land, plants, ani-
mals, and people encountered. This illus-
tration from the Pacific Railroad Survey is
one of the best to evoke the circumstances
and numbers of bison on the Plains.*

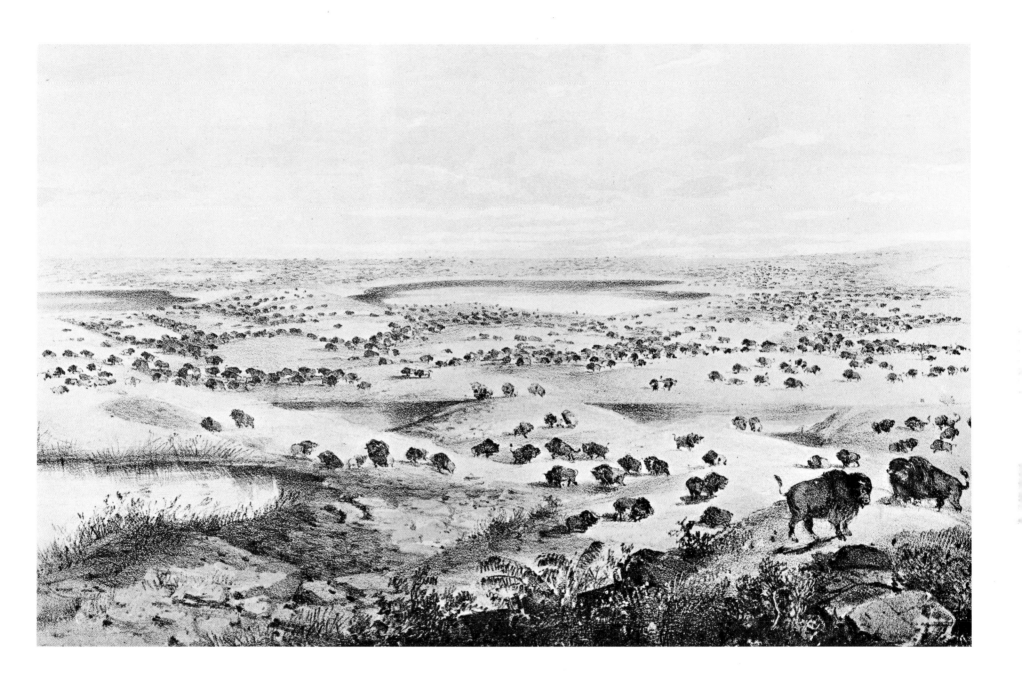

95

PIKES PEAK OR BUST. Alex Comparet, 1870. Oil on canvas. 26 x 32 inches (framed). Courtesy State Historical Society of Colorado, Denver. *Alex Comparet's comment* *regarding one of the immigrants headed to Colorado was later published in* Harper's Weekly *in 1873 under William Cary's signature.*

MEDICINE BUFFALO OF THE SIOUX. George Catlin, 1837–1839. Oil on canvas. 19⅝ x 27⅝ inches. Lent by the National Collection of Fine Arts; courtesy the Department of Anthropology, Smithsonian Institution. *The central importance of the buffalo to Plains Indian life led to the creation of many rituals. Catlin observed the Sioux dancing and chanting to the buffalo spirit represented by the figure cut in the turf before a hunt.*

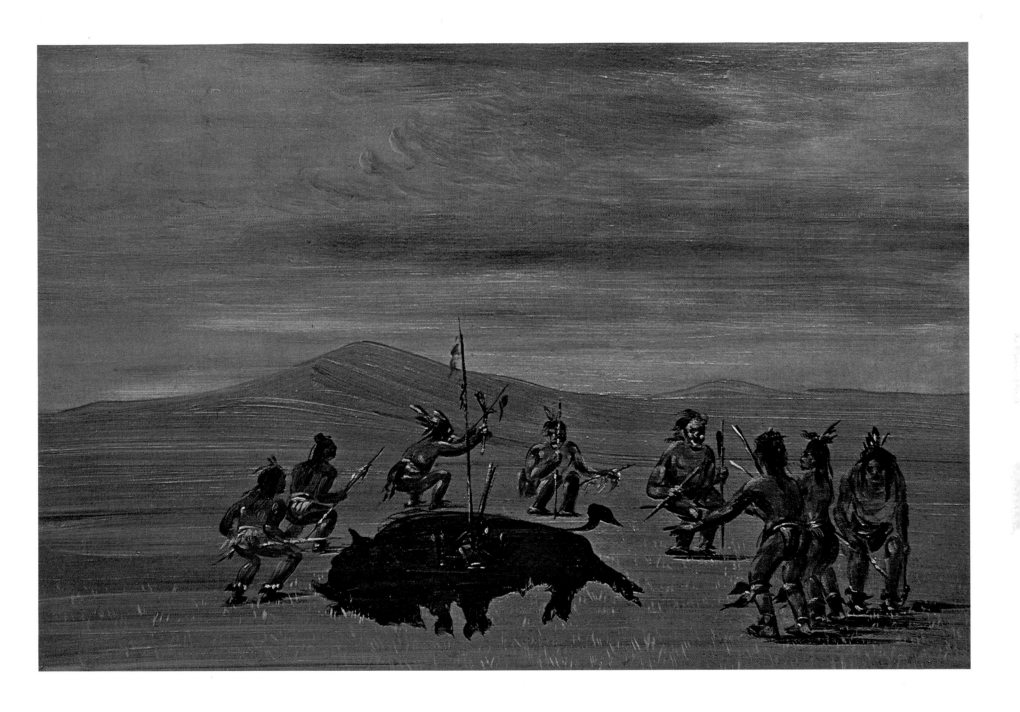

THE TOURISTS' TRIP ACROSS THE PLAINS. "WE ARE ALL RIGHT UP TO THE PRESENT TIME." 1881. Toned lithograph. 30⅜ x 40 inches. Courtesy Amon Carter Museum, Fort Worth. *This poster, advertising the play* The Tourists' Trip *caricatured the great adventure of the day, the trip across the continent. The buffalo image had so pervaded the artist's imagination that he drew bison as beasts of burden, something they never were used for, but which makes for an amusing picture.*

LIBERTY HALL, NEW BEDFORD, WEDNESDAY EVENING, SEPTEMBER 21.

The most Talented Comedy and Musical Organization in the World.

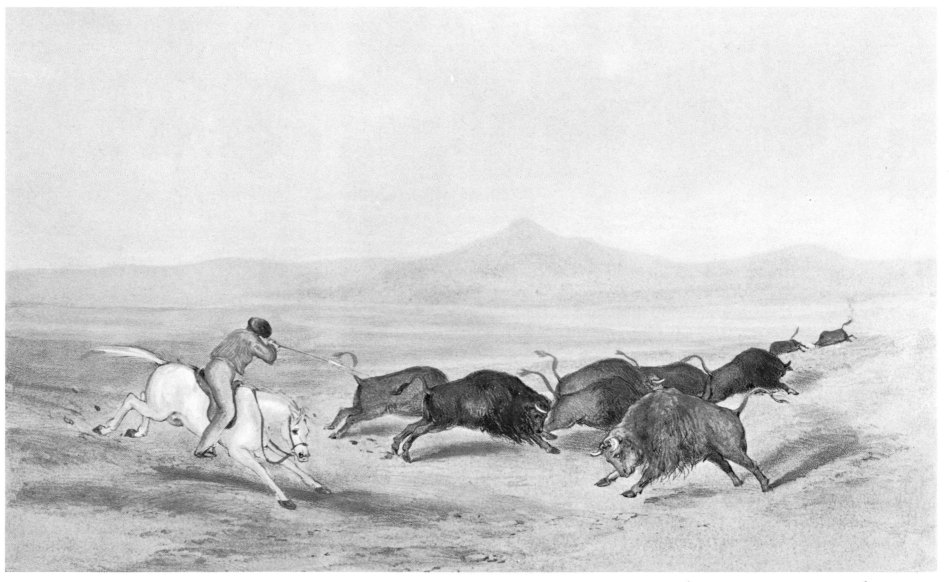

BUFFALO HUNTING ON THE W. PRAIRIES. Henry James Warre, circa 1848. Toned lithograph (hand-colored). Composition: 7⅜ x 11¾ inches. Courtesy Amon Carter Museum, Fort Worth. *With a secret Canadian military mission to the West, Warre* *investigated American intrusion into Hudson's Bay Company lands in Oregon Territory in 1845. The sketches he did on the expedition were later lithographed and published in his* Sketches in North America and the Oregon Territory.

99

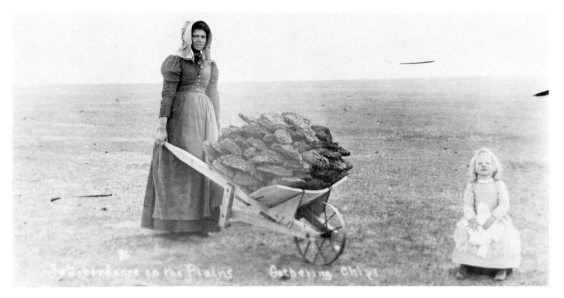

INDEPENDENCE ON THE PLAINS. n.d. Photograph made from the original print in the collection of the Kansas State Historical Society, Topeka. *The Plains settlers changed their way of life in many ways to accommodate the circumstances of the "Great American Desert." There they could no longer obtain the firewood that had been so plentiful in the East, but buffalo "chips" made a glorious fire and contributed to the independence needed to live successfully on the Plains.*

BUFFALO HERDS CROSSING THE UPPER MISSOURI. George Catlin, 1832. Oil on canvas. 11¼ x 14¼ inches. Lent by the National Collection of Fine Arts; courtesy the Department of Anthropology, Smithsonian Institution. *Determined to become the chronicler of the Plains Indians and hoping to see them before they were exterminated by disease and white man, George Catlin ascended the Missouri River as far as Fort Union in 1832. He observed Blackfoot and Crow Indians there, then returned downriver by canoe, accompanied by two fur trappers as guides. There he saw the buffalo: "The river was filled, and in parts blackened, with their heads and horns, as they were swimming about . . . and making desperate battle whilst they were swimming." The standing figure is Catlin, who fought to keep the animals away from the canoe.*

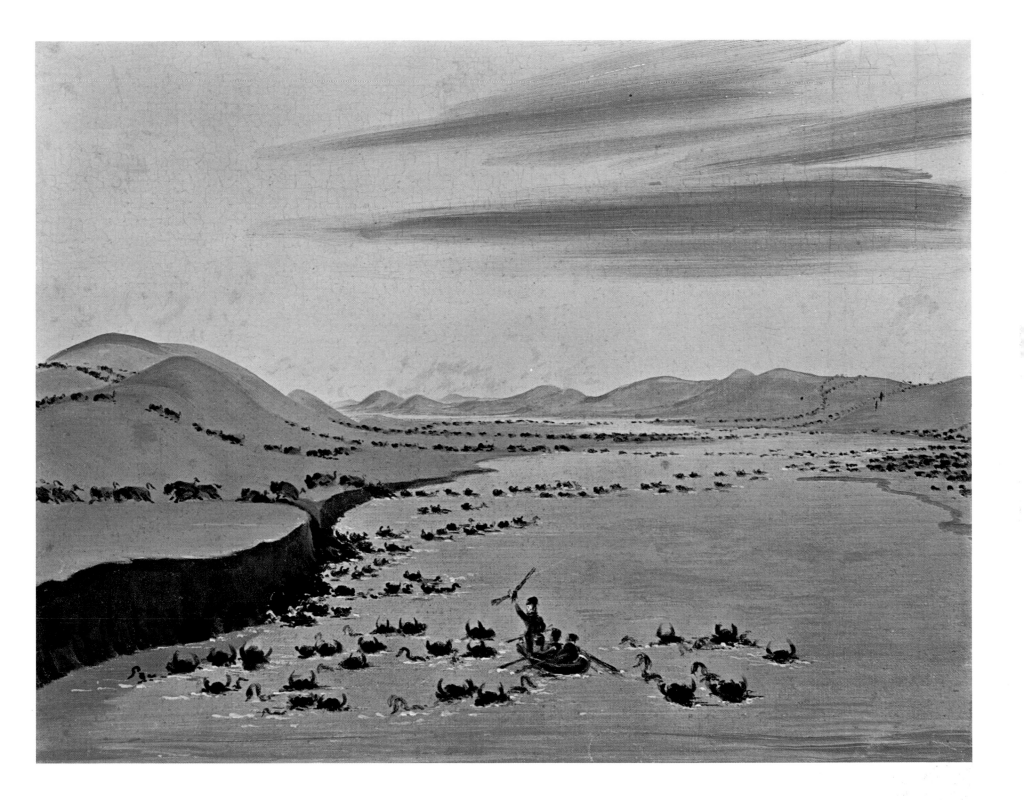

THE STAMPEDE. William J. Hays, 1862. Oil on canvas. 36 x 72⅛ inches. Courtesy Glenbow-Alberta Institute, Calgary. *Hays painted* The Stampede *as a companion to* The Herd on the Move *(page 61). Both paintings focus on the awesome power of* the bison herd. The Herd *portrays the placid implacability of their seasonal migrations, while* The Stampede *depicts them in frenzied flight from an unknown menace toward some place of sanctuary.*

THE SILK ROBE. Charles M. Russell, circa 1890. Oil on canvas. 27⅝ x 39⅛ inches. Courtesy Amon Carter Museum, Fort Worth. *From knowledge gained by spending a winter with the Blood Indians on the Canadian border in 1888, Russell depicts two women employing their skills in preparing a buffalo skin. After "fleshing" the hide, which pared it to half its natural thickness, the women tanned it by repeated heatings and greasings with a concoction derived from various buffalo organs. An especially fine robe required ten days of steady labor and was deemed a "silk robe" because of its soft, pliant texture and the sheen of its fur.*

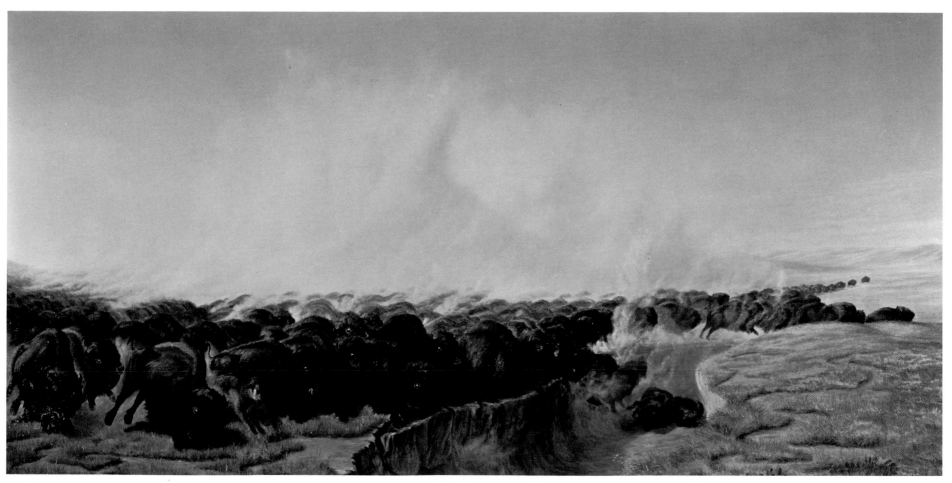

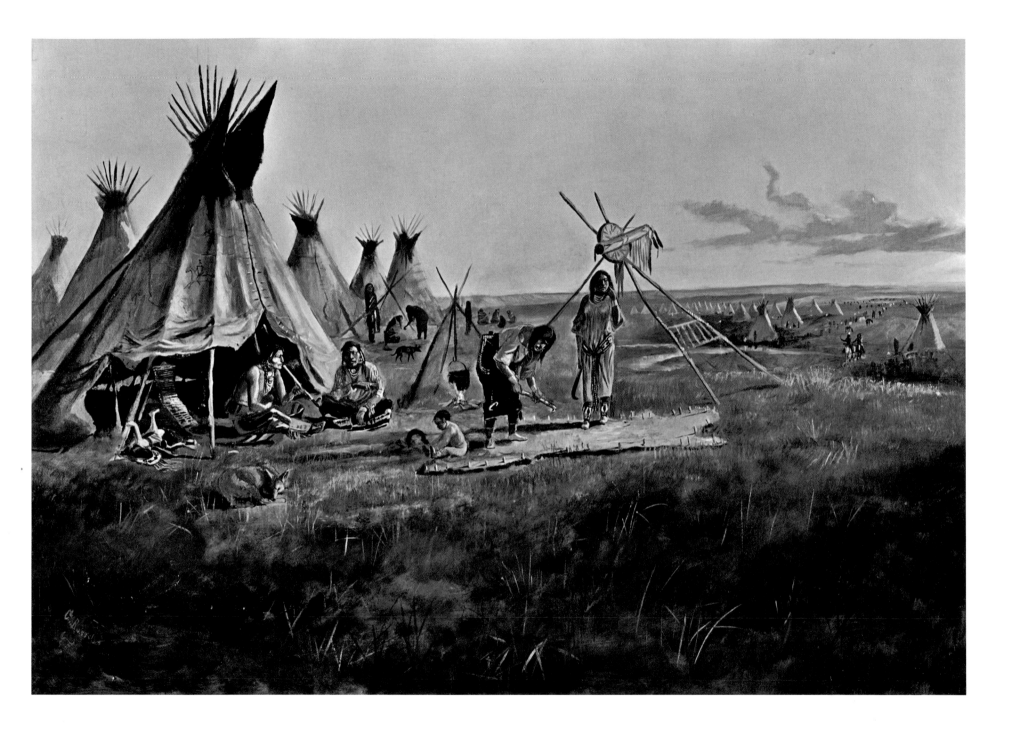

THE SURROUND. Alfred Jacob Miller, n.d. Oil on canvas. 65 x 93½ inches. Courtesy Joslyn Art Museum, Omaha. *A masterpiece of impressive action, The Surround depicts hunters riding in circles around a herd until a tired buffalo can be singled out for the kill. Executed at Stewart's family home, Murthly Castle, the composition contains the three figures from the Buffalo Hunt (page 65) in the foreground, while the enormous picture conveys the expansive grandeur of the Plains landscape.*

A SWELL SPORT STAMPEDED.
By Jove-I say! Was that an Earthquake?

A SWELL SPORT STAMPEDED. Thomas Worth, 1882. Lithograph (hand-colored). Published by Currier & Ives. 13½ x 17¾ inches. Courtesy Amon Carter Museum, Fort Worth.

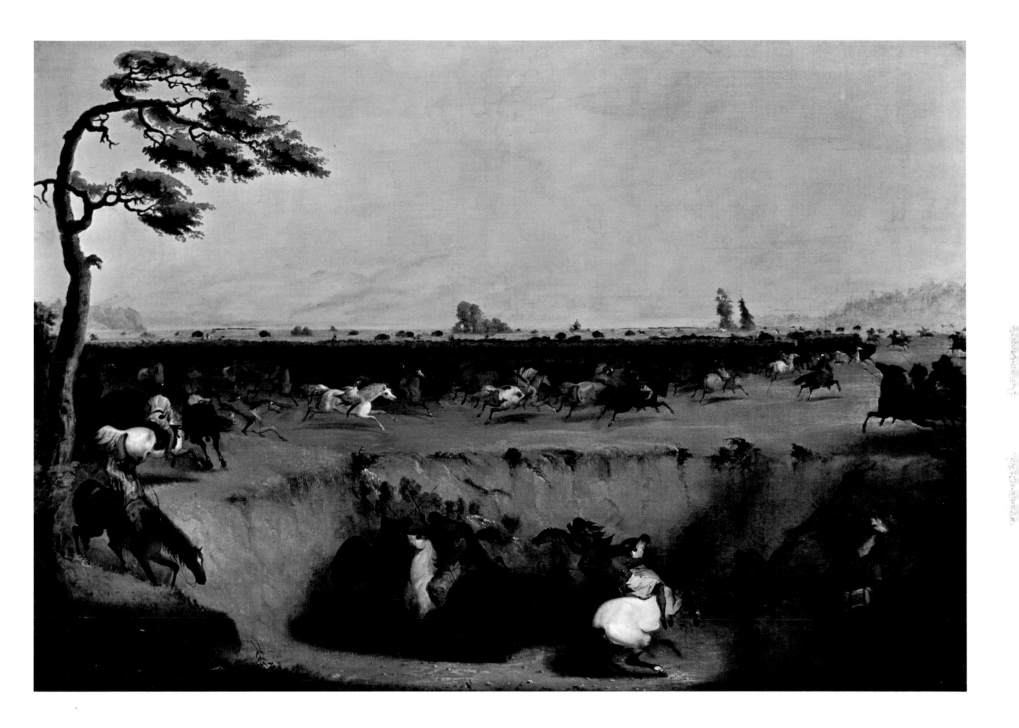

105

LIFE ON THE PRAIRIE. THE "BUFFALO HUNT."
Arthur Fitzwilliam Tait, 1862. Toned litho-
graph (hand-colored). Composition: 18⅝
x 27 inches. Courtesy Amon Carter Muse-
um, Fort Worth. *Tait was another of the
Currier & Ives artists who had not seen the
West. He was an Englishman who came to
America in 1850 and established a studio
in New York City. He was soon an associ-
ate of the National Academy of Design
and specialized in outdoor and sporting
scenes. Most of his information on the
West came from Catlin and Bodmer prints
in the collection of the Astor Library.*

WILD WEST SHOW FLAG. 1890. Blue muslin.
50 x 70 inches. Courtesy Buffalo Bill His-
torical Center, Cody, Wyoming. *The buf-
falo was frequently used as a symbol be-
cause of Buffalo Bill's association with the
shows. Other shows also used the word
and symbol, such as the Buffalo Ranch
Wild West.*

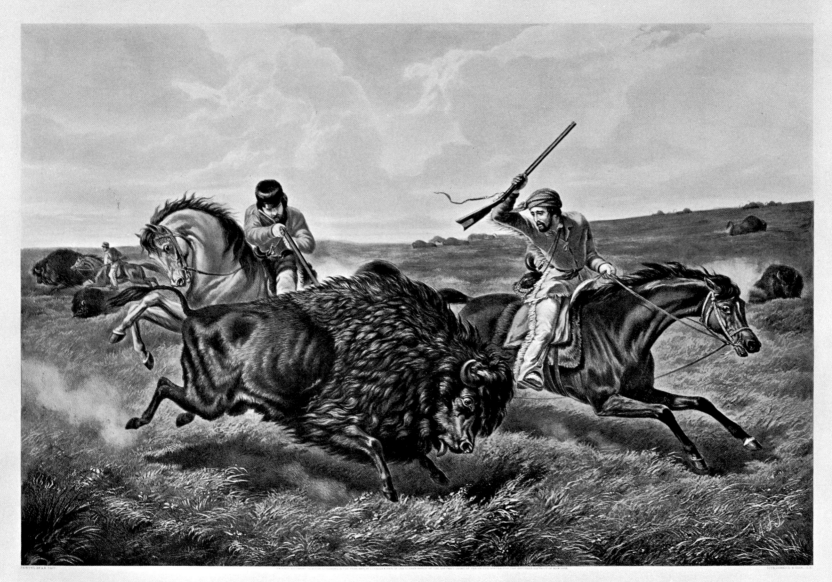

LIFE ON THE PRAIRIE.

The "Buffalo Hunt".

NEW YORK PUBLISHED BY CURRIER & IVES, 152 NASSAU STREET.

JE VIENS. Circa 1889. Color lithograph. 30 x 40 inches. Courtesy Buffalo Bill Historical Center, Cody, Wyoming. *Buffalo Bill printed posters to advertise his "exhibition" wherever he went. This rare French poster has an English equivalent — "I Am Coming."*

THIS INDIANS THREE MAN BOW AND ARRAY SHOOT KILL BUFFALO. Making Medicine, 1877. Lady's folding fan, tempera on silk. 9 x 17 inches. Courtesy St. Augustine Historical Society. *The drawings of the Fort Marion Indian prisoners became popular as tourist items, and many ladies sub-* *mitted their fans for decoration. Making Medicine (1844–1931) painted this one with a Cheyenne buffalo hunt for Miss Annie Pidgeon. In its dedication to her, however, the renegade substituted the Cheyenne word for owl, a detested creature, for the word pidgeon.*

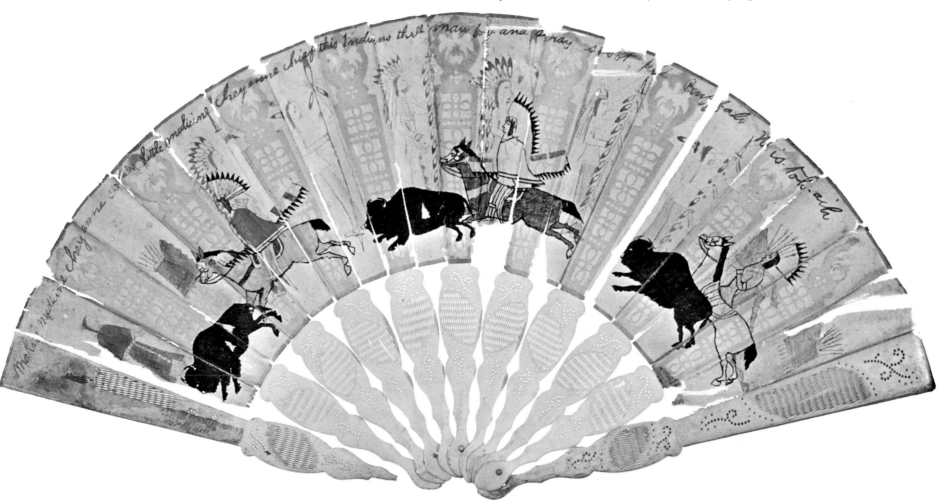

109

Documenting the Decline

SHOOTING BISON FROM A UNION PACIFIC TRAIN. Walter Lockhart, 1931. Oil on canvas. 38 x 48 inches (framed). Courtesy Kansas State Historical Society, Topeka. *"Some of the railroads running far out into the prairies have regular trains for parties of amateur hunters, who fire upon their victims from the car windows,"* reported the December 12, 1874, edition of Harper's Weekly. *"Thousands of buffalo were killed in this manner . . . and their carcasses left to decay on the ground along the line of the railroad."*

SHOOTING THE BUFFALO. Charles M. Russell, circa 1892. Oil on canvas. 27 x 33 inches. Courtesy Amon Carter Museum, Fort Worth. *The meat was used to feed the work crews on the railroad. The hunters, like Buffalo Bill, received high salaries for their work — sometimes as much as five hundred dollars a month.*

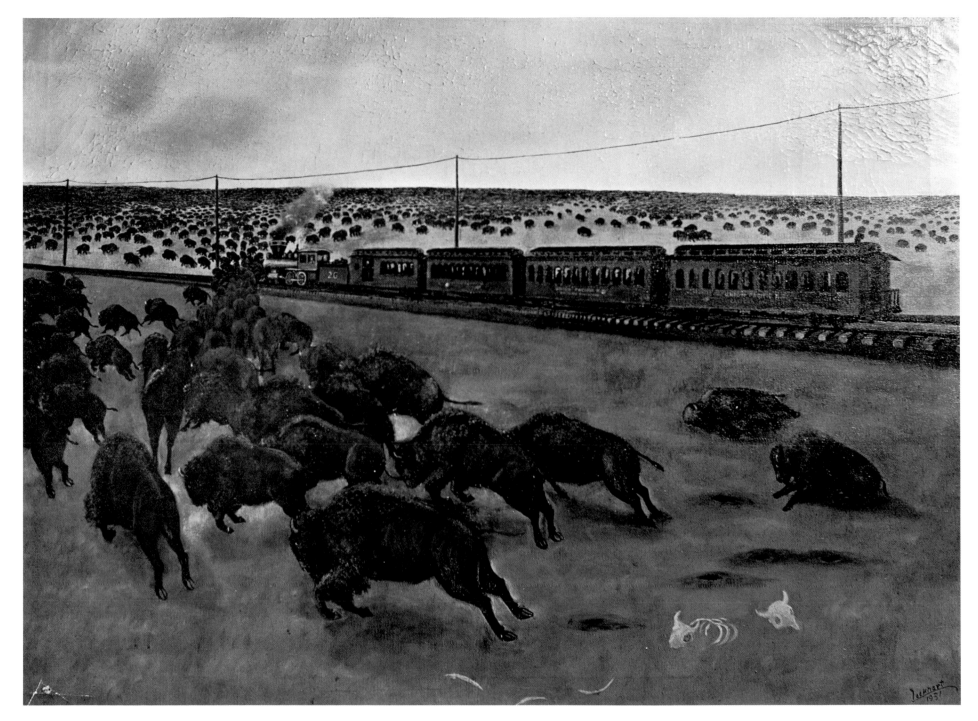

111

SLAUGHTERED FOR THE HIDE. Paul Frenzeny and Jules Tavernier, *Harper's Weekly*, December 12, 1874. Engraving (hand-colored). 13⅜ x 10⅞ inches. Courtesy Amon Carter Museum, Fort Worth. *"The hides are taken off with great skill and wonderful quickness, loaded on a wagon . . . and carried to the hunters' camp,"* reported Harper's Weekly. *"Our artists spoke with hunters on the plains who boasted of having killed two thousand head of buffalo apiece in one season."* Some hunters even used horses to peal off the buffalo hide.

BUFFALO SKULL. n.d. Bone. 29-inch horn spread. Courtesy Amon Carter Museum, Fort Worth. Gift of C. Bland Jamison, Santa Fe, New Mexico. Fort Worth only. *The proud possessor of this skull was killed on President Theodore Roosevelt's ranch in Dakota Territory.*

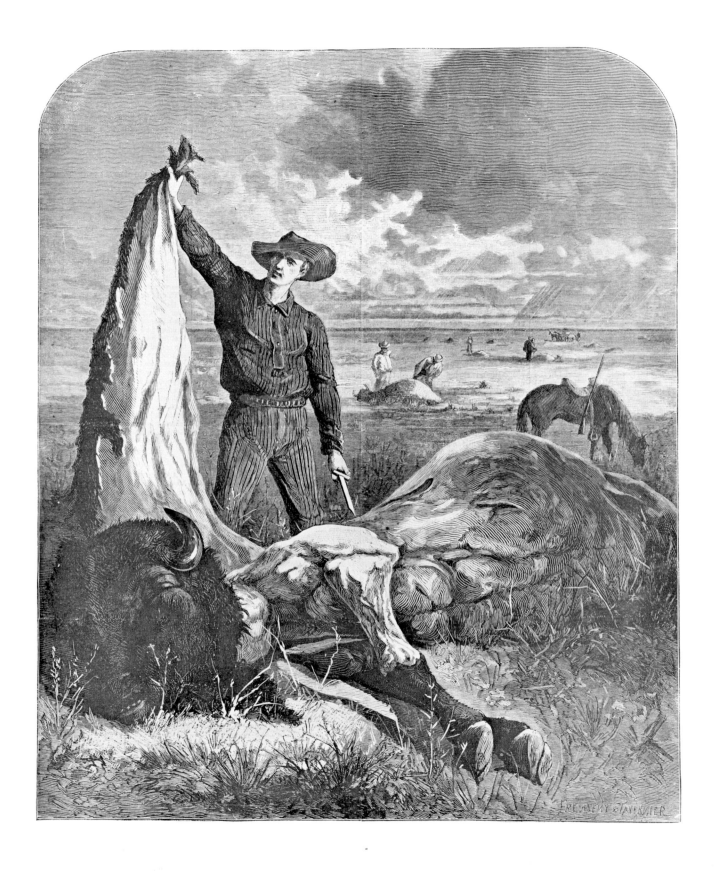

SHARPS BREECH-LOADING "OLD RELIABLE" BUFFALO RIFLE. 1870. .45 caliber, octagonal barrel. 47 inches long. Courtesy Buffalo Bill Historical Center, Cody, Wyoming. *The "old reliable" Sharps was the most* *widely used breech-loading, single-shot rifle in the American West. Also known as the big "50," the Sharps weighed between seventeen and eighteen pounds and usually cost one hundred dollars.*

THE HIDE HUNTERS, 1872. Martin S. Garretson, 1913. Pen and ink on paper. 16¼ x 24⅞ inches (sight). Courtesy William Reese, Fred White, Jr., Frontier America Corporation. *Buffalo could be hunted for sport and game, but when the professional hunter exercised his trade he often did it on foot in the midst of a herd with a Remington or Sharps rifle (see* Shooting the Buffalo, *page 110, and* Sharps Buffalo Rifle, *page 114). As the hunters approached the herd, they tried to kill the leaders. The* *herd often would stand still for the ensuing slaughter, unless one animal was only wounded and created a disturbance. The hunters worked as a team with one or two hunters, five or six skinners, and another two or three men to stretch the hides and drive the wagons. Garretson has pictured a "still" hunt in this drawing. The hunters are up on the ledge, firing down into the herd, while the skinners work in the foreground, far enough from the herd to cause no disturbance.*

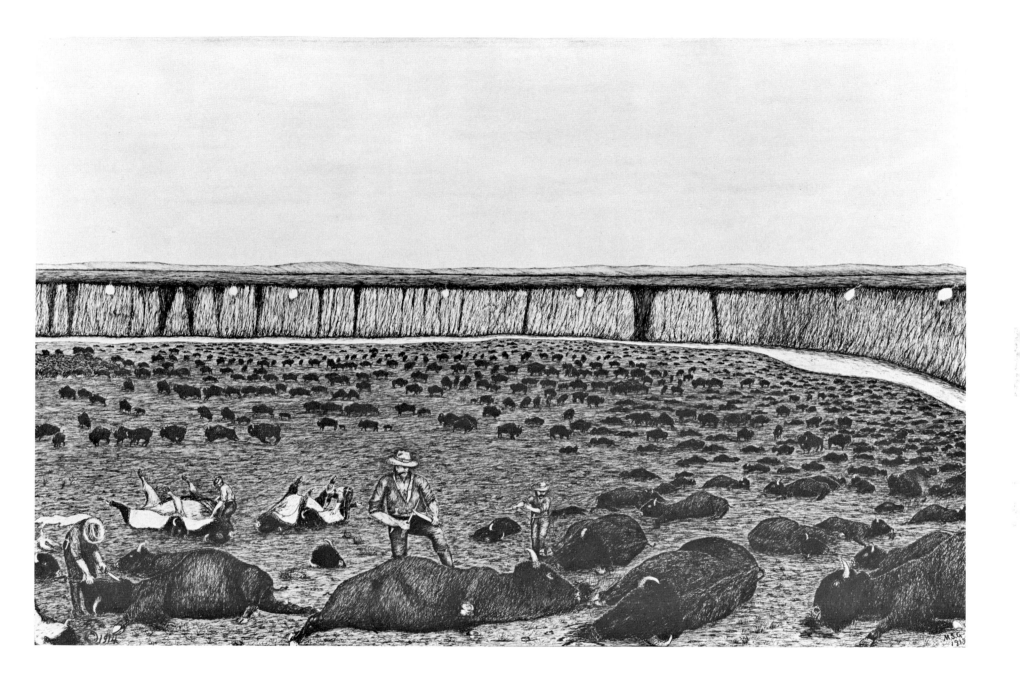

115

HUNTING PARTY, MONTANA. F. Jay Haynes, photographer, 1882. Print made from original negative in the collection of the Haynes Foundation. *F. Jay Haynes, the well-known photographer of Yellowstone* *National Park, photographed the death of one of the few bison left on the Montana range at the hands of this 1882 hunting party.*

THE GREAT AND CRUEL SLAUGHTER OF BUFFALOES IN THE YEARS 1867 & 8 — FROM MEMORY BY L. W. A. L. W. Aldrich, n.d. Oil on canvas. 16 x 26 inches. Courtesy Joslyn Art Museum, Omaha. *When news of Buffalo Bill's feat — he supposedly killed 4,280 buffalo during his tenure with the Kansas Pacific Railroad — reached others, professional hunters came by the score to slaughter the buffalo. The best documented kill during a single season, however, was the famous lawman Billy Tilghman, who gathered 3,300 hides between September 1 and the following April 1.*

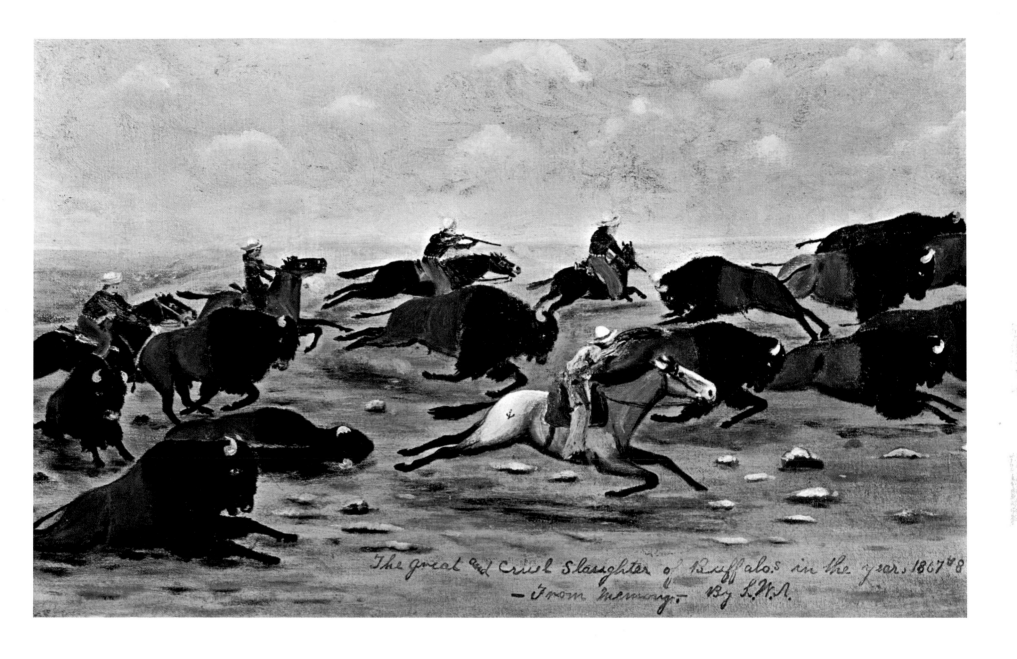

The great and cruel Slaughter of Buffalos in the year 1867 & 8
— From memory. By L.W.A.

117

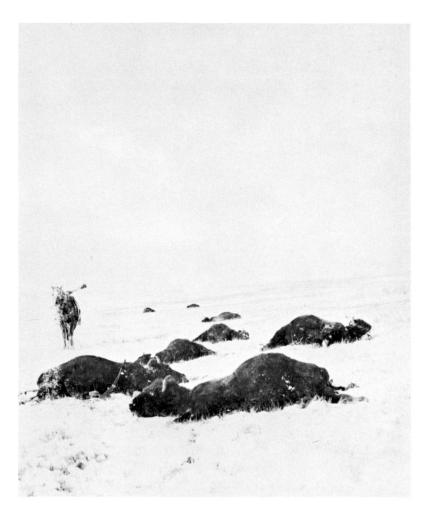

BUFFALO KILLED, SMOKY BUTTE, MONTANA. L. A. Huffman, photographer, 1882. Print made from original print in the collection of Glenbow-Alberta Institute, Calgary. *L. A. Huffman was another photographer who followed the professional buffalo hunters. They killed as many animals as they could before stopping to skin them.*

BUFFALO SKINNERS AT WORK. L. A. Huffman, photographer. Print made from original print in the collection of Glenbow-Alberta Institute, Calgary. *The skinners, usually working in pairs, stripped the buffalo hide as quickly as possible. They rolled the animal on its back, cut off the head and used it as a brace to keep it in this position. The skin was then split from tail to chin and cut off at the knee and back joints.*

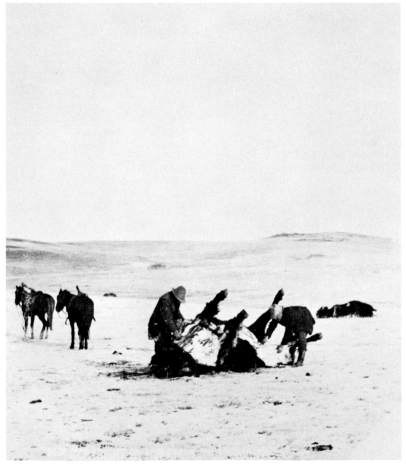

BUFFALO HIDE COAT. n.d. Buffalo hide with black wool lining. 54½ inches long. Courtesy Buffalo Bill Historical Center, Cody, Wyoming. *Old frontiersmen and soldiers believed that there was more warmth in a buffalo coat than any other, and that one buffalo coat equalled four wool blankets. The government purchased thousands of buffalo coats for the army.*

THE END, 1883. Martin S. Garretson, 1913. Pen and ink on paper. 16¼ x 24⅞ inches (sight). Courtesy William Reese, Fred White, Jr., Frontier America Corporation. *The thousands of buffalo left on the Plains soon rotted away to bones. Then came the* bone hunters, who gathered them up and sold them for prices ranging from seven to nine dollars per ton for plain bones, twelve to fifteen dollars per ton for hoofs and horns. Here Garretson pictures the grim work that meant a great deal of money to *freighters who drove across the Plains, because they did not have to return empty — they could return with a profitable load of buffalo bones.*

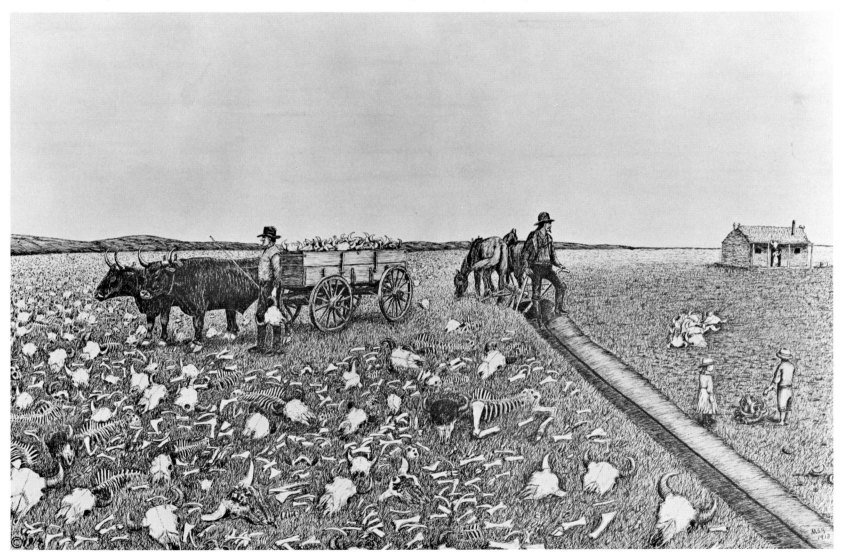

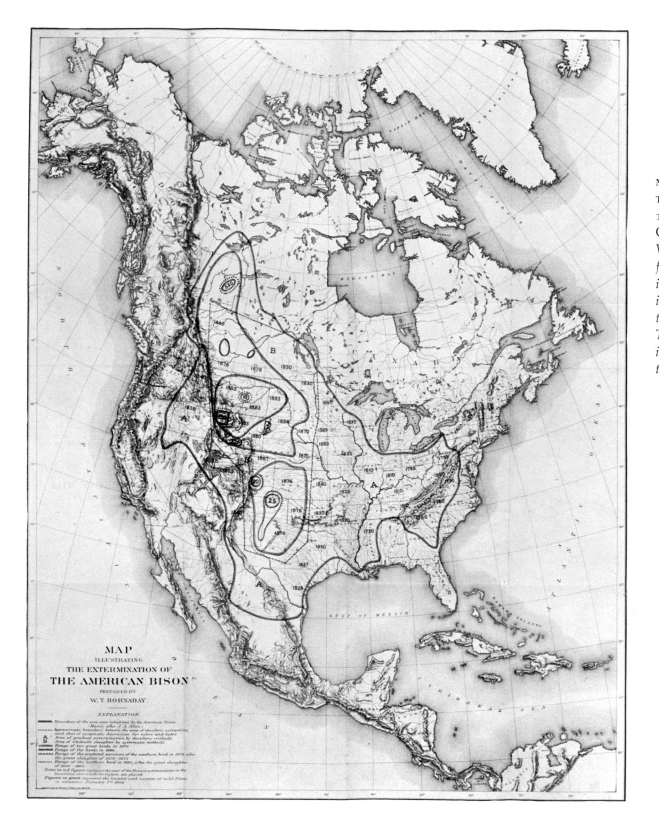

MAP ILLUSTRATING THE EXTERMINATION OF THE AMERICAN BISON. W. T. Hornaday, 1889. Color lithograph. 24 x 18¼ inches. Courtesy Amon Carter Museum, Fort Worth. *Hornaday was surprised to find so few bison during his reconnaissance trips in the West. This map, with its increasingly smaller circles, shows the range of the animal from prehistoric times to 1889. The small green circles indicate the range in 1889. The numbers inside them indicate the actual number of bison in that range.*

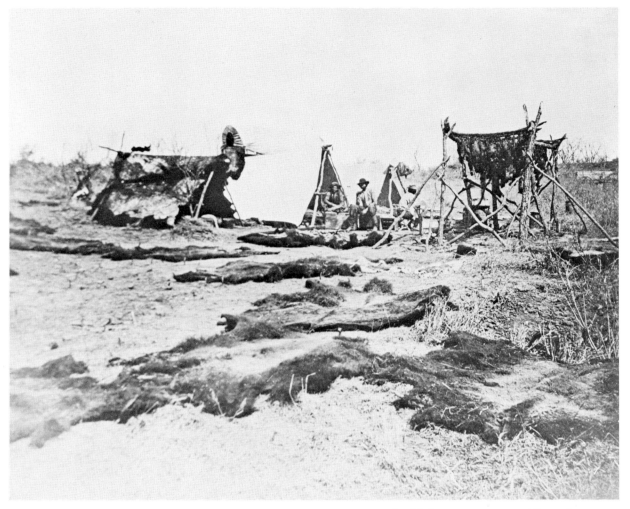

BUFFALO HIDE HUNTERS' CAMP ON EVANS CREEK, NEAR BUFFALO GAP IN THE TEXAS PANHANDLE. George Robertson, photographer, 1874. Print made from the original print in the Western History Collections, University of Oklahoma, Norman. *These hunters have stretched their hides out to dry on the ground. Buffalo tongues are hanging on the rack at the right.*

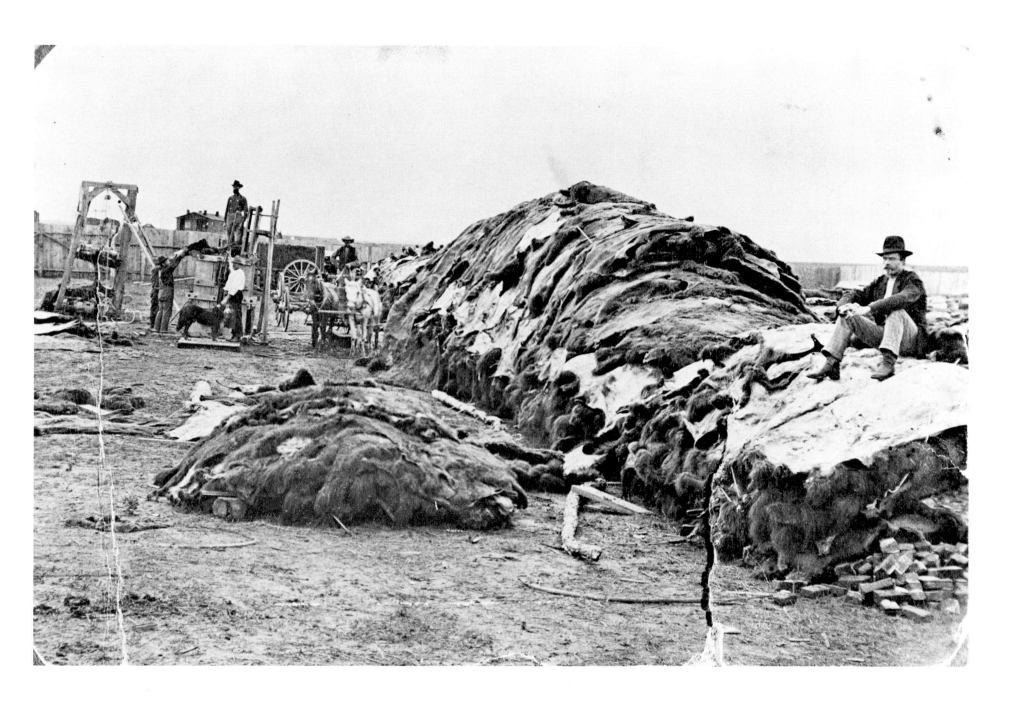

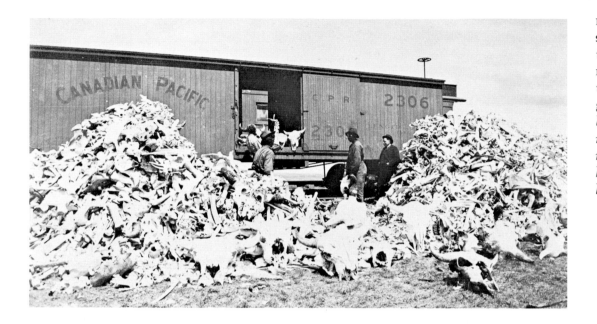

PILES OF BUFFALO SKULLS AT THE RAILROAD SIDING, SASKATOON. Hugh Lumsden, photographer, August 9, 1890. Photograph made from the original print in the collection of the Glenbow-Alberta Institute, Calgary. *There were incredible amounts of the bones. This pile gives a good idea, but one rick of bones along the Santa Fe Railroad near Grenada, Colorado, was twelve feet high, twelve feet wide, and half a mile long.*

BUFFALO BONES READY FOR LOADING ON CANADIAN PACIFIC RAILROAD BOXCAR. Buell, photographer, circa 1885. Photograph made from original print in the collection of Glenbow-Alberta Institute, Calgary. *The bones were shipped to marketing centers where they were used in refining sugar, making buttons, combs, knife handles, and other items. The hooves were used to make glue.*

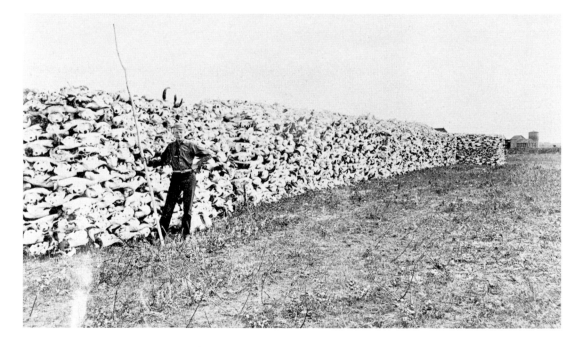

THE BUFFALO HEAD. Ashley D. M. Cooper, circa 1890. Oil on canvas. 40 x 36 inches. Courtesy Buffalo Bill Historical Center, Cody, Wyoming. *Trophies of the hunt were also common, so it is no surprise that a leading* trompe l'oeil *painter such as Cooper would include this buffalo head in a still life painting.*

BUFFALO HORN CHAIR. Circa 1890. 44 x 24 x 18 inches. Eight pairs of graduated horns, leather. Courtesy Mr. and Mrs. Frederic G. Renner. *Some parts of the animal served somewhat more decorative purposes. Buffalo horn chairs were rather common toward the end of the nineteenth century.*

126

PROUD DISPLAY AT THE GENERAL OFFICES OF THE KANSAS PACIFIC RAILWAY COMPANY, KANSAS CITY, MISSOURI. R. Beinecke, photographer, circa 1869. Photograph made from the original print in the collection of Everett L. DeGolyer, Jr.

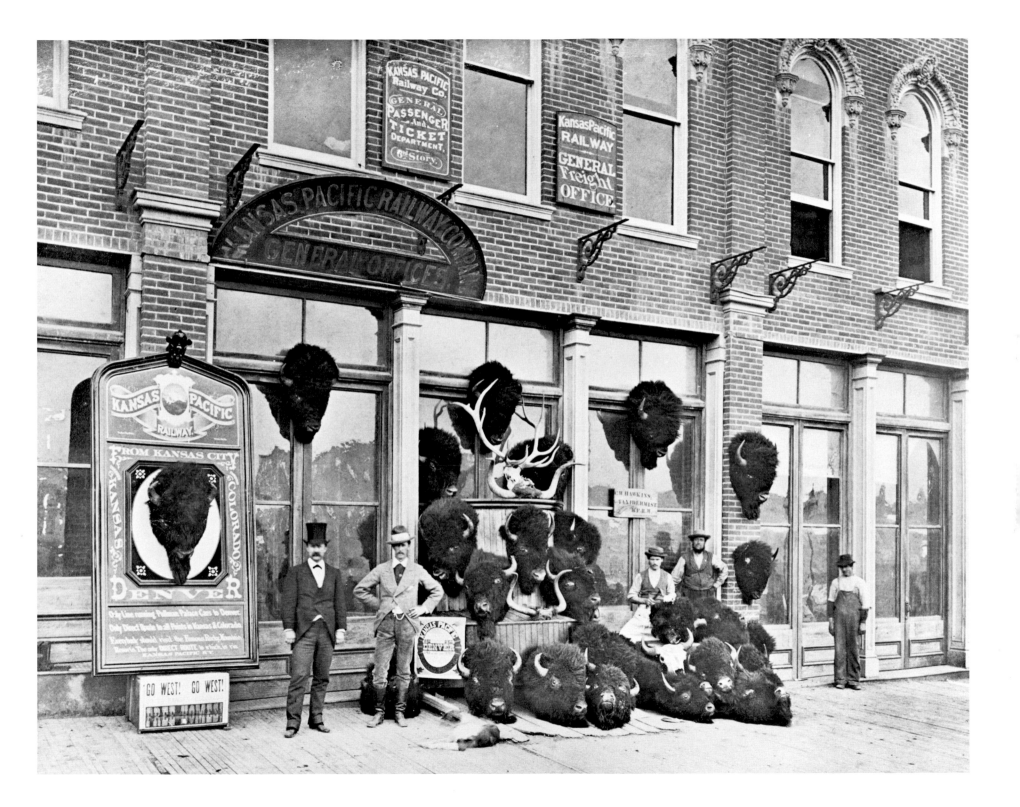

Conservation

BUFFALO HERD. James Earle Fraser. 1950 (recent cast). Modern Art Foundry, Long Island City, N.Y. Bronze. 13 inches high. Courtesy Kennedy Galleries, Inc., New York City. *Fraser, the sculptor of the bison on the nickel, returned to the animal for a subject late in his life. Using the buffalo in the Bronx Zoo as his models and remembering the early descriptions of the herds, he sculpted this herd in the impressionistic technique of his earlier years.*

PABLO-ALLARD BUFFALO DRIVE. Charles M. Russell, 1909. Watercolor. 8½ x 11½ inches. Courtesy Mr. and Mrs. Frederic G. Renner. *In 1908 the Canadian government bought part of the famous Pablo buffalo herd on the Flathead Indian Reservation in Montana, probably the largest extant herd. The hand-picked crew of 75 Montana cowboys managed to corral 120 buffalo, which were then shipped to Wainwright and put on a preserve. Russell, as a guest of the Canadian officials, was present to record the roundup in this picture.*

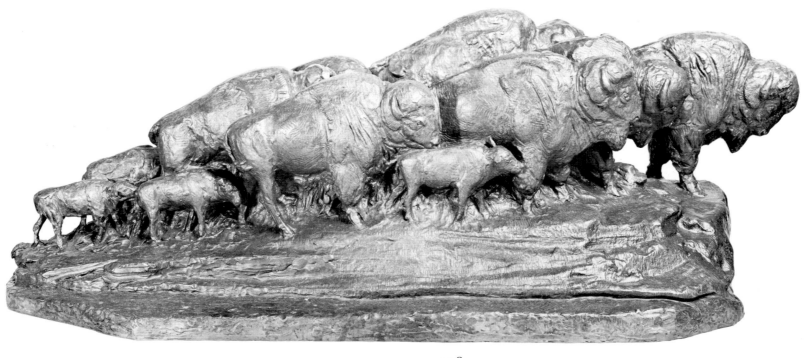

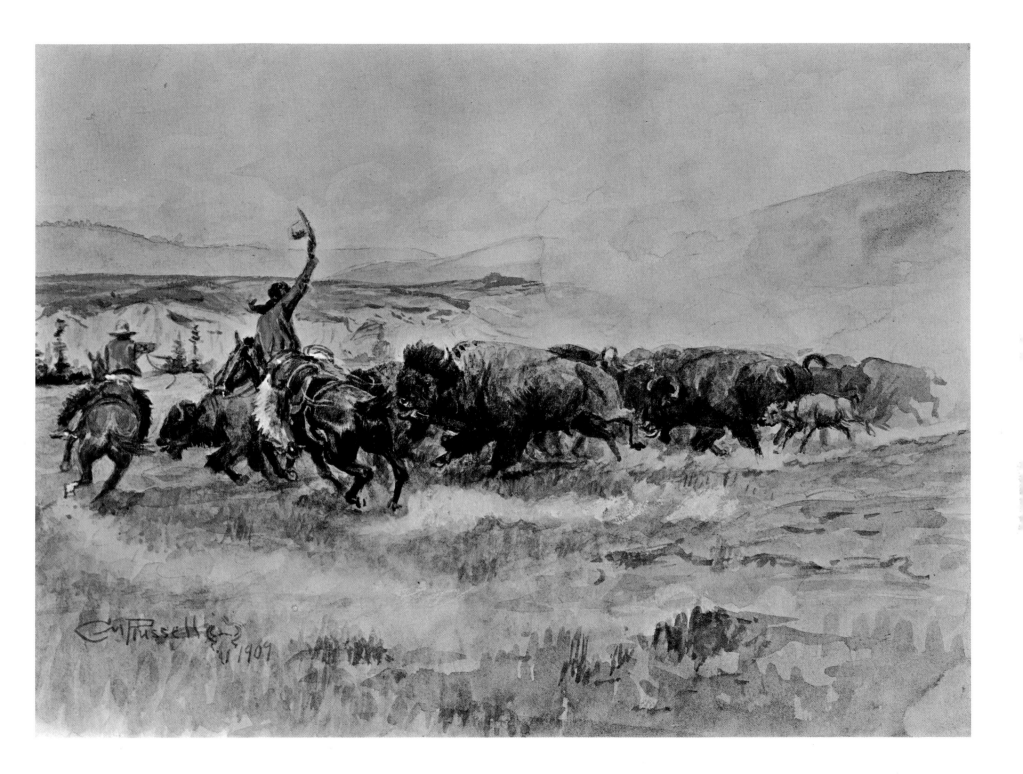

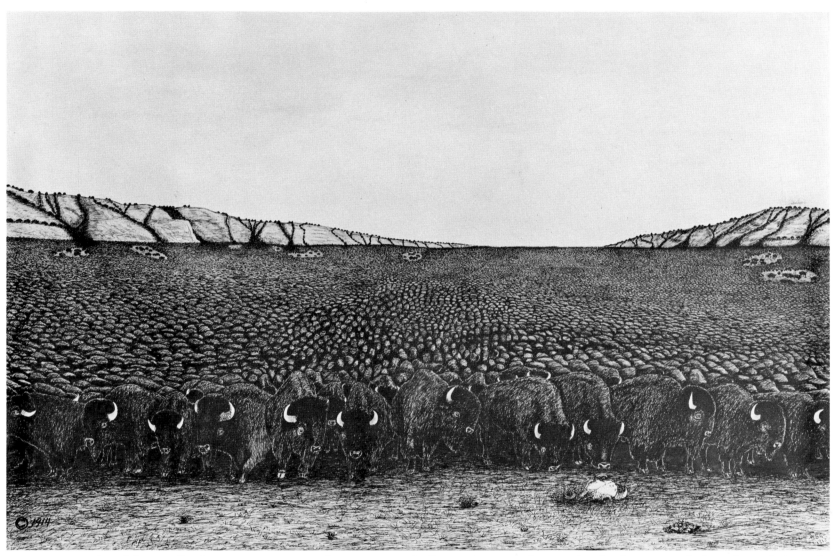

THE HERD, 1860. Martin S. Garretson, 1913. Pen and ink on paper. 16⅛ x 24¾ inches (sight). Courtesy William Reese, Fred White, Jr., Frontier America Corpora- tion. *In a picture similar to Hays's* The Herd on the Move, *Garretson has graphi- cally illustrated the many eye-witness ac- counts that he accumulated of the buffalo herds that roamed the Plains before the great slaughter took place.*

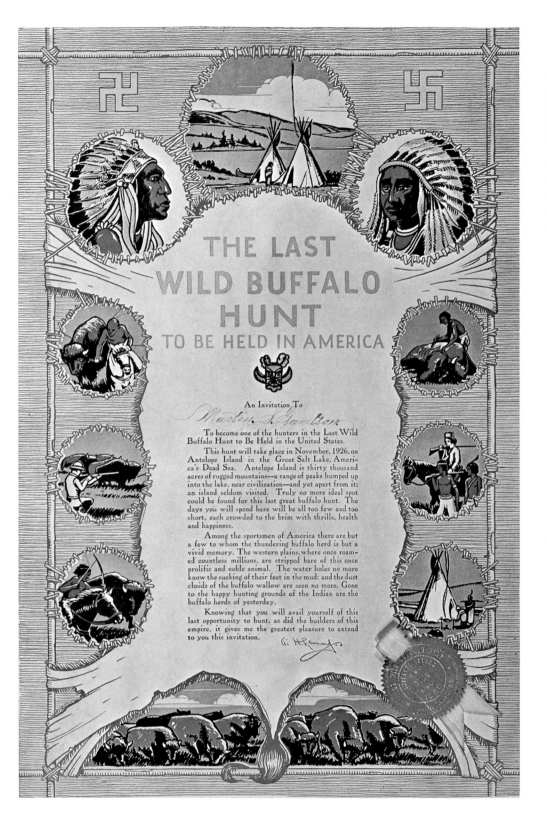

THE LAST WILD BUFFALO HUNT TO BE HELD IN AMERICA. 1926. Color lithograph, with seal. 12¾ x 9⅝ inches. Courtesy William Reese, Fred White, Jr., Frontier America Corporation. *A. H. Leonard sent out lithographed posters as invitations to the hunt, conducted on Antelope Island, in the Great Salt Lake, Utah. This was Garretson's invitation, which he framed and hung in his office.*

BUFFALO NICKEL. Obverse: *Indian Profile.* Reverse: *Buffalo Head.* James Earle Fraser. Cast 1969. Bronze. 4½ inches diameter each. Courtesy Mr. William Shay. Photograph courtesy Kennedy Galleries, Inc., New York City. *The best-known image of the buffalo is probably the Fraser sculpture that appears on the reverse of the Buffalo Nickel. When asked by the Treasury Department to design the coin in 1913, Fraser's desire was to produce a "truly American" coin that "could not be confused with the currency of any other country." The American buffalo was the most distinctive motif he found. Charles M. Russell's comment was, "damn small money for so much meat."*

THE "Q" STREET BUFFALO. A. Phimister Proctor, 1912. Bronze. 13¼ inches high. Courtesy Mr. and Mrs. Arthur J. Phelan, Jr. *After receiving the commission to do four large bronze buffaloes for the Q Street Bridge in Washington, D.C., Proctor visited Wainwright to see the buffalo herd held captive on a two-hundred-thousand-acre preserve. This is the study for the large bronzes, which measure nine feet high and eighteen feet long and occupy the four corners of the bridge.*

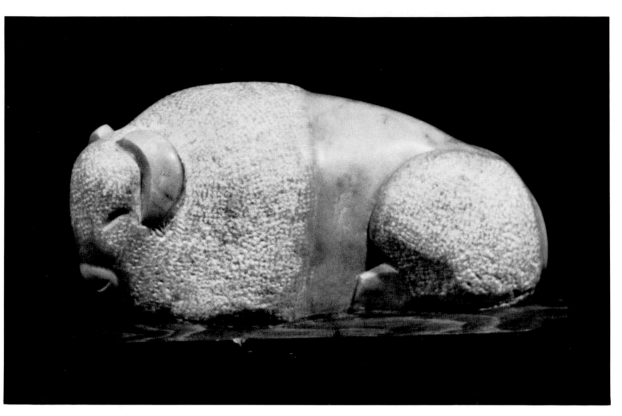

[Resting buffalo.] Roy Rafael, n.d. Stone. 10 inches high. Courtesy Institute of American Indian Arts, Santa Fe. Contemporary Navajo artist Roy Rafael has evoked in a small stone sculpture the solid, monumental strength which makes the bison an impressive and enduring symbol.

MARTIN S. GARRETSON IN HIS BRONX ZOO
OFFICE. October, 1931. Photograph made
from the original print in the collection of
the Conservation Library Center, Denver
Public Library. *As head of the National
Museum of Heads and Horns, Garretson
was a well-known authority on the buffalo
and served as secretary of the American
Bison Society for years.*

PROGRESS I. Luis Jimenez, 1973. Fiberglass with epoxy coating. 8 feet, 8 inches high. Courtesy Mr. Donald B. Anderson. Fort Worth only. *The image of the buffalo is still strong among Southwestern peoples. In a work replete with regional symbols, Jimenez has dramatically depicted the ultimate death of the buffalo, perhaps a symbol for the millions of animals that roamed the Plains during the first half of the nineteenth century but were reduced to a mere handful by 1900.*

The Exhibition

137

Index

Picture captions are by Karen Dewees, Kay Krochman, and Ron Tyler of the Amon Carter Museum staff.

The authors and publishers gratefully wish to acknowledge permission to publish the watercolors by Karl Bodmer from the Northern Natural Gas Company Collection, Joslyn Art Museum, reproduced in: *People of the First Man,* edited by Davis Thomas and Karin Ronnefeldt. E. P. Dutton & Co., Inc., 201 Park Avenue South, New York, New York, 1976.

About the Author

LARRY BARSNESS was born and raised in Lewistown, Montana, in the state's central Judity Basin cow country painted by Charlie Russell. As a child, he first saw Russell's paintings hanging in the glass cases in Sid Willis's Mint Saloon in Great Falls. His parents lived near "Teddy Blue" Abbott's ranch where Larry heard many of his stories and saw the illustrated letters Abbott had received from Charlie. At one time he went to school in the ghost town of Gilt Edge, where after school the children played in an abandoned barber shop, store, bank, and church, walked the catwalks of the old cyanide mill, and talked to old miners.

Later Larry spent twenty years in Montana's restored territorial capital, Virginia City, aiding in the restoration there and operating the Opera House. He listened to old-timers' yarns, and read all of the old newspapers — clear back to '63. Out of this came his book, *Gold Camp*, published by Hastings House.

He attended the universities of Montana, Iowa, Washington, and Oregon, taking a B.S. at Iowa and an M.S. at Oregon. He has taught writing at the University of Montana since 1965.

He has published articles in *Montana: the Magazine of Western History*, and *The American West*; the University of Montana Forestry School uses his writing manual, *Alternatives to Boring Writing*. He serves as writing consultant to two Montana governmental agencies.

During summers Larry and his wife operate a summer theater on Flathead Lake in Pohlson, Montana.